IMAGES
of America

HISTORIC
EASTON

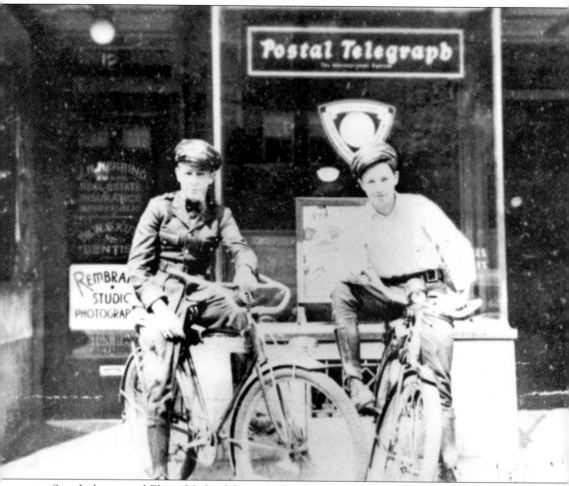

Sam Indorato and Elwood Lake delivered telegrams after school in 1938. The years following the Great Depression were difficult, and young people worked hard to supplement the family income.

IMAGES
of America

HISTORIC EASTON

Marie Summa, Frank Summa, and Leonard Buscemi Sr.

ARCADIA

Copyright © 2000 by Marie Summa, Frank Summa, and Leonard Buscemi Sr.
ISBN 0-7385-0493-9

Published by Arcadia Publishing,
Charleston SC, Chicago IL, Portsmouth NH, San Francisco CA

Printed in Great Britain

Library of Congress Catalog Card Number: 00-104076

For all general information, contact Arcadia Publishing:
Telephone 843-853-2070
Fax 843-853-0044
E-mail sales@arcadiapublishing.com
For customer service and orders:
Toll-free 1-888-313-2665

Visit us on the Internet at www.arcadiapublishing.com

CONTENTS

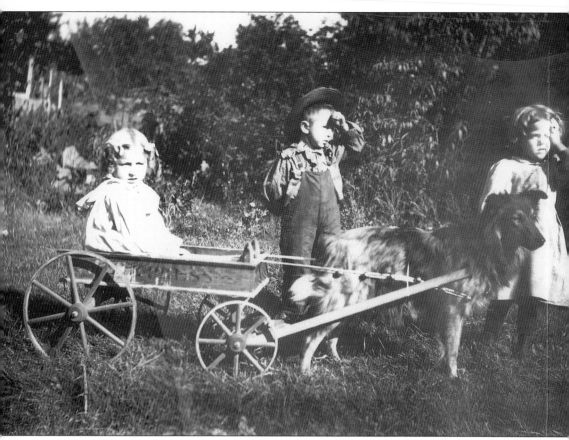

The faithful family dog can provide many amusements, as is illustrated by this photograph taken by Norma McFall Collmar, a noted Easton photographer. Collmar captured this image on July 8, 1898 in the backyard of her South Fifth Street home.

INTRODUCTION

Easton is located at the confluence of the Delaware and Lehigh Rivers, with the Delaware providing its eastern border with New Jersey. Since colonial days, Easton's strategic location along these two major rivers and a smaller tributary, the Bushkill Creek, made it a major trade and shipping center. In later years, its abundant waterpower brought significant industrial sites to Easton.

Set among sparkling rushing waters and rolling wooded hills, Easton's beauty has been much acclaimed. A 19th-century historian, whose favorite vantage point was a hill called Mount Olympus, just north of the Lafayette College campus, commented, "Men may go to Europe, climb the Alps to get a glimpse of scenery no more beautiful than that which greets the eye of the beholder from the summit of this Mount Olympus."

Thomas Penn, the second son of William Penn's second marriage, made his first trip to Pennsylvania in 1732. His father had died in 1718, and the land office had remained inactive since then. Numerous squatters had moved onto Penn family holdings, illegally claiming the land. With the family burdened by debt, Thomas determined to settle affairs in the Pennsylvania province. Joined by his brother, John Penn, Thomas departed from his father's beliefs and policies. When William Penn arrived in America, the land he called his "Holy Experiment," he dealt fairly and honestly with the Native Americans, recognizing them as the rightful owners of the land. He stated in his treaties that the natives and the white man "must live in love as long as the sun gives light." His relationship with them gained him such respect that they called him "Brother Onas," and also conferred that title to all in his government. His sons, however, did not share his idealism, having grown up in a time when trusted associates cheated their father, and only a few close friends kept him out of debtor's prison. Thomas and John became involved in the infamous Walking Purchase, no doubt persuaded by William Allen and James Logan. Allen had amassed huge land holdings, and Logan had a partnership in the Durham Iron Works, south of Easton, which had depleted its lumber supply. Additional land openings would benefit both of these men.

Once the Walking Purchase had been established, Easton became a reality, both as a town and a county seat. Shortly after its founding, three log houses stood in the town. By September 1752, there were 12 families located there. William Parsons listed these heads of households and their occupations: William Parsons, clerk of courts; Lewis Gordon, lawyer; Henry Alshouse, carpenter; Abraham Berlin, smith; Nathaniel Vernon, ferryman; William Craig, Paul Miller, and John Anderson, tavern keepers; Ernest Becker, baker; Anthony Esser, butcher; John Finley, mason; and Myer Hart, shopkeeper.

William Parsons is perhaps the best recognized of these men. Sometimes called the "Father of Easton," he laid out the town in the style of old Philadelphia. As a clerk of courts and prothonotary, he represented the provincial administration.

Lewis Gordon, Easton's first lawyer and later the operator of the ferry house, played a major role in the various peace treaties that took place during the French and Indian War. However, torn between loyalties, he initially refused to back the Revolutionary War and was placed under arrest. Almost immediately, he was paroled with the stipulation that he not cross to the east side of the Delaware River, leaving him unable to tend to his ferry. This wealthiest of Easton men died in 1778, saddened at having lost his position in society.

Henry Alshouse, Abraham Berlin, and John Finley applied their skills to building the town. Alshouse raised money to build the courthouse. In addition to his other blacksmith duties, Berlin prepared ironwork for the jail, and Finley built its walls.

Paul Miller, one of the three tavern keepers, also plied his trade of stocking weaving. As a Catholic in a society where anti-Catholic sentiment was strong, he managed to secure a tavern license, whereas a later Catholic arrival was refused one because of his religion. William Craig and John Anderson, supporters of the Proprietary party, gained exclusive rights to sell liquor in the newly settled town for the first six months, but Nathaniel Vernon soon broke their monopoly. Myer Hart, who was Jewish, apparently gained success in his business as a merchant, subsequently becoming an innkeeper and amassing a number of properties in Easton. Esser and Becker supplied the community with food, with Ernest Becker carrying flour from Bethlehem to his back to supply his bakery.

Easton's population grew slowly. The town was incorporated as a borough in 1789, containing about 700 residents. With the Industrial Revolution, almost 11,000 people populated the town, setting the stage its city charter, granted on January 12, 1887.

Volumes could be written about Easton's rich history, but in the following brief sketch, we have tried to present highlights of some of the city's most memorable events, landmarks, and citizens with the best accuracy we could muster. Please forgive any errors or omissions.

One

THE FOUNDING

OF A COUNTY

Long before European settlers arrived in the city now known as Easton, this and surrounding areas was the habitat of the Lenni Lenape tribe. Unlike their Iroquois neighbors to the north, the Lenape were peaceful. They called this place *Lechauwitank*, meaning "the place at the forks."

It is believed that a there was never a permanent settlement of Lenapes in early Easton proper. It is known, however, that it was one of their favorite locations for fishing and hunting parties, as well as a meeting ground for councils. Various campgrounds have been detected on the hillsides close to the old city boundaries. Their tranquil lifestyle lasted until they were supplanted by the aftermath of the infamous Walking Purchase of 1737.

Thomas Penn, eager to develop the area, traveled with his brother, John, to the Forks in the summer of 1735. Entranced by the wild scenic beauty of this area and its strategic location, he began negotiating for land rights with both the Iroquois and Lenapes. Thomas and John Penn produced a deed of sale that they stated their father had acquired in 1686, claiming land as far as a man could walk in a day and a half.

Below is a draft of the Thousand-Acre Tract surveyed to Thomas Penn in 1736. Anticipating the Walking Purchase, and perhaps a county seat at this location, Penn arranged a survey. Accompanied by surveyor general Benjamin Eastburn, he visited the Forks and selected the land. William Parsons and Nicholas Scull laid out the town of Easton in 1752 on this tract.

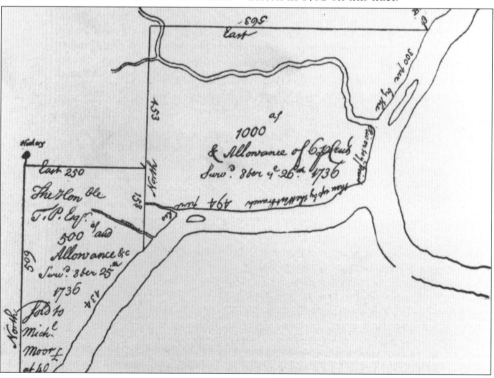

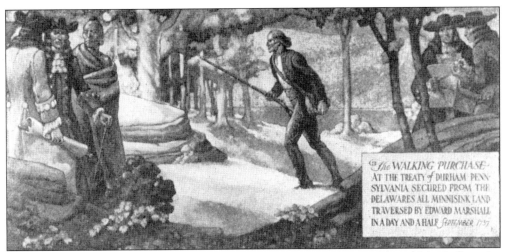

George Gray painted this mural of the Walking Purchase. It depicts Edward Marshall in the company of Lenape braves. Early at sunrise on the morning of September 17, 1737, Edward Marshall, Solomon Jennings, and Edward Yeates set out to mark the western boundary of the purchase. Marshall strode with ax in hand for better gait, advancing at such a rapid pace that Jennings quit after 18 miles. Angry Lenape escorts left in later afternoon, shouting at Marshall not to run. At sunrise on the following day, Marshall began at the same furious pace. Fellow "walker" Yeates collapsed and died three days later.

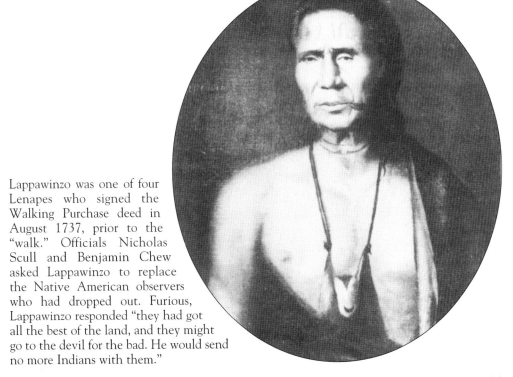

Lappawinzo was one of four Lenapes who signed the Walking Purchase deed in August 1737, prior to the "walk." Officials Nicholas Scull and Benjamin Chew asked Lappawinzo to replace the Native American observers who had dropped out. Furious, Lappawinzo responded "they had got all the best of the land, and they might go to the devil for the bad. He would send no more Indians with them."

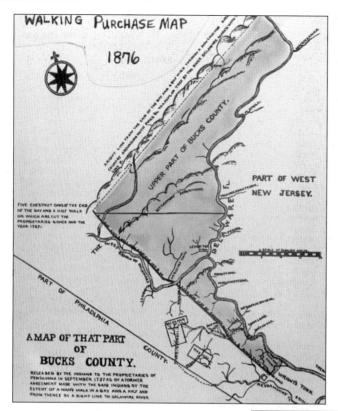

WALKING PURCHASE MAP

1876

PART OF WEST
NEW JERSEY.

FIVE CHESTNUT OAKS AT THE END
OF THE BAY AND A HALF WALK
ON WHICH ARE CUT THE
PROPRIETARIES NAMES AND THE
YEAR 1737.

PART OF PHILADELPHIA

A MAP OF THAT PART
OF
BUCKS COUNTY.

RELEASED BY THE INDIANS TO THE PROPRIETARIES OF
PENNSILVANIA IN SEPTEMBER 1737 AS BY A FORMER
AGREEMENT MADE WITH THE SAID INDIANS BY THE
EXTENT OF A MAN'S WALK IN A DAY AND A HALF AND
FROM THENCE BY A RIGHT LINE TO DELAWARE RIVER.

The shaded area of the map indicates property gained as a result of the walk, about 1,200 square miles. The line on the left shows the route of the walk coursed in a northwesterly direction, and not, as the Lenapes believed, straighter and closer to the Delaware River. The walk began at a chestnut tree near Wrightstown, Pennsylvania, and ended near the town of present-day Jim Thorpe, Pennsylvania. Edward Marshall had walked a phenomenal 65 miles in 18 hours. Adding further indignity, surveyors drew the survey line in a northeast direction to the Delaware River.

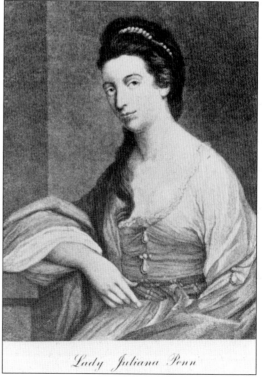

Lady Juliana Penn

On August 22, 1751, Thomas Penn married Lady Juliana Fermor, the fourth daughter of Lord Pomfret of Easton-Neston, Northamptonshire, England. To honor his new bride, the newly formed county was named Northampton. Its county seat was called Easton and Easton's first streets were named Juliana, Pomfret and Fermor. Lady Juliana died in 1801, never having seen Easton, the town her bridegroom had founded to pay her tribute.

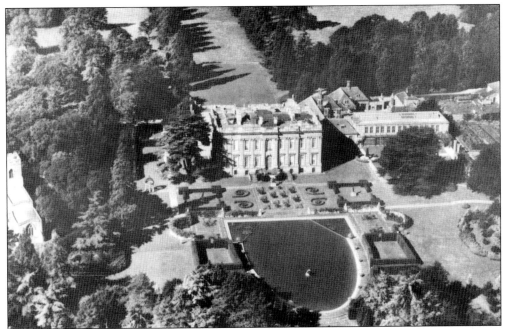

This contemporary photograph shows the estate of Lord Fermor, of which Easton and Northampton County are a namesake.

When Easton became a town, the only building there was the ferry house, built by David Martin between c. 1739 and 1742, with historians differing about the precise date. Its location at the confluence of the Delaware and Lehigh Rivers provided a convenient site for ferrying passengers and goods across both waterways. David Martin died in December 1751, and his demise caused a struggle between William Parsons and Nathaniel Vernon for ferry rights.

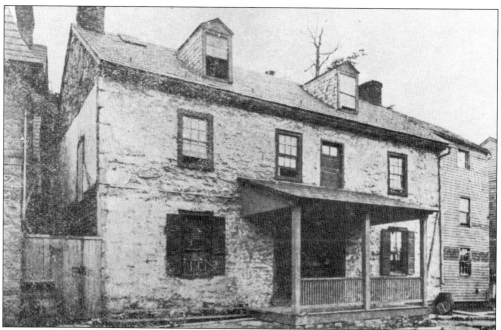

Nathaniel Vernon won a lawsuit that William Parsons brought against him for ferry rights. He continued to run the ferry and ferry house until November 1758. John Rinker leased the ferry house for a short time, followed by Lewis Gordon, who held the ferry lease from 1761 to 1783. Sometime during that period, the old log structure was rebuilt.

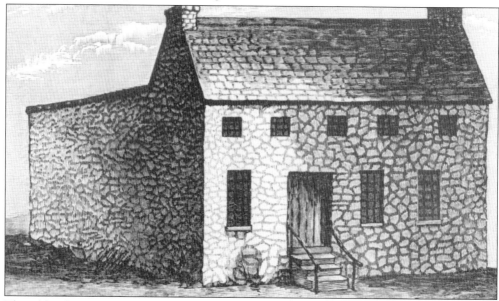

The old jail, Easton's first public building was built in 1752, shortly after the formation of Northampton County. It served a dual purpose, both as an area to confine lawbreakers and as a place of refuge during the French and Indian War. Its sturdy stone walls, however, did not prevent the escape of prisoners during the Pennamite War, when 20 Connecticut political prisoners escaped on September 17, 1784, having overpowered the jailkeeper. The jail was torn down in 1851.

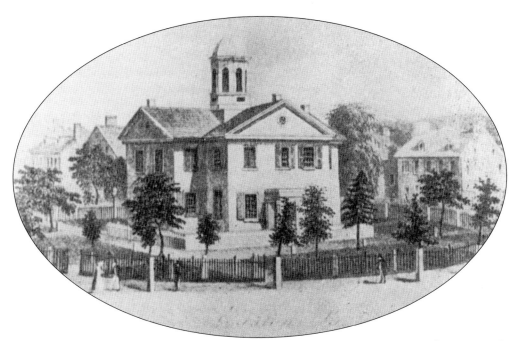

Lacking a courthouse, the first Northampton County Court session convened on June 17, 1752. It was an informal gathering, either held outdoors or in the ferry house, since no other buildings existed at that time. For eleven years after that, sessions were held in local taverns. This first courthouse was erected on Public Square, adjacent to the jail, built earlier. Between the courthouse and Pomfret Street stood the pillory and whipping post.

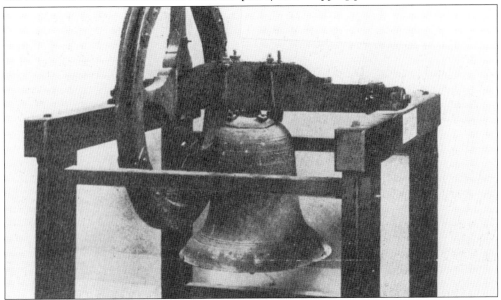

This bell, cast at the Moravian's bell foundry in Bethlehem, was placed in the cupola of the old courthouse on August 9, 1768. Initially, it was used to announce important events in the town, such as vital meetings and fires. It pealed joyously after a hushed silence as Robert Levers read the Declaration of Independence from the old courthouse steps on July 8, 1776. "Easton's Liberty Bell" is now housed at the government center.

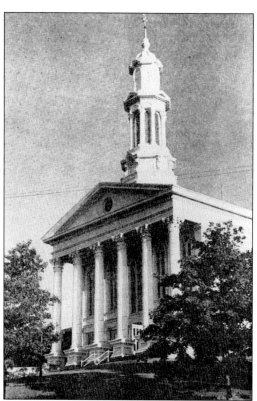

After much debate about its new location, the new courthouse, with its handsome Greek Revival porch, was completed in November 1861 on Walnut Street, with its first court session held on November 18 that year. The majority of lawyers had wanted the courthouse to be built on the old foundation, but most citizens did not want the square filled with a public building. Today, the courthouse is part of the Northampton County government center complex.

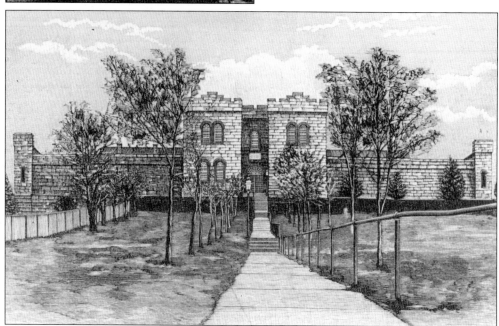

Once the new courthouse was erected, Easton's construction began on the third county prison in 1868, taking three years to complete at a cost of almost $200,000. Previously, a second jail had been built near the old jail lot. The whipping post and pillory, those torturous instruments of frontier justice, had been discontinued by 1790.

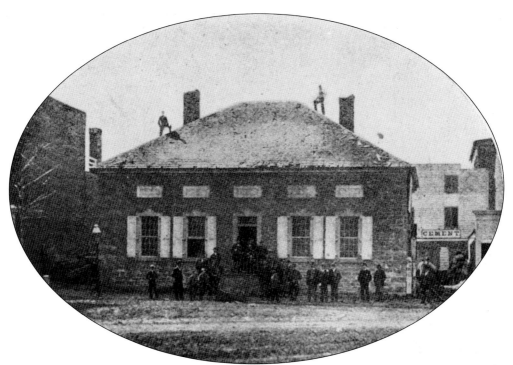

The busy courthouse soon ran out of space, and the county records building—or the county building, as it was also known—was built in 1795 on the south side of the square, east of Pomfret Street. The prothonotary and clerk of the orphan's court moved into it shortly after it was built.

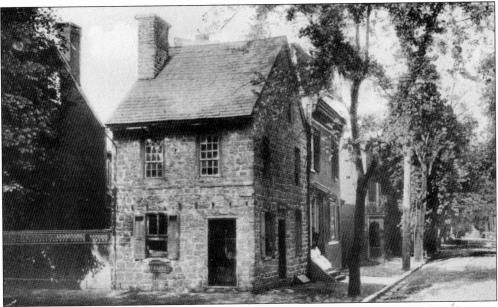

Known as the Parsons-Taylor House, this home was originally built in 1757 for William Parsons, Easton surveyor, and later occupied by George Taylor. Located at Fourth and Ferry Streets, the building is one of the most important city landmarks.

George Taylor—friend of George Washington, member of the Continental Congress, drafter of a 1765 petition urging the King of England to repeal the hated Stamp Act, and signer of the Declaration of Independence—occupied the Fourth and Ferry Street house shown on the previous page. It is believed that Taylor entertained George Washington there when he came to Easton to visit hospitalized patients housed in the Reformed Church. Taylor died in the Parsons-Taylor House on February 28, 1781, not living to see the war's end and America's victory. He is buried in Easton's old cemetery.

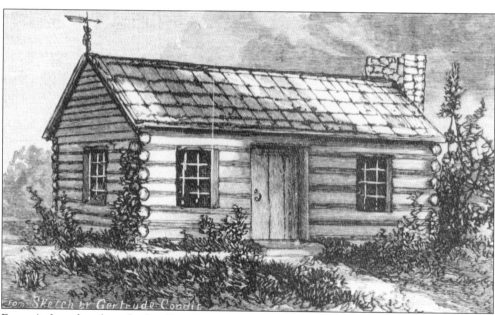

Easton's first church and schoolhouse was a one-story log structure with three rooms. It was built in 1755 and funded by citizens' subscriptions as well as the donations from an educational trust raised in Holland and England. Residents of Easton donated time and some materials. Lutheran and Reformed denominations held services here in early days. The building, located just east of the Third Street Reformed Church, was one of the first structures erected on North Pomfret Street.

Two

ALONG THE
WATERWAYS

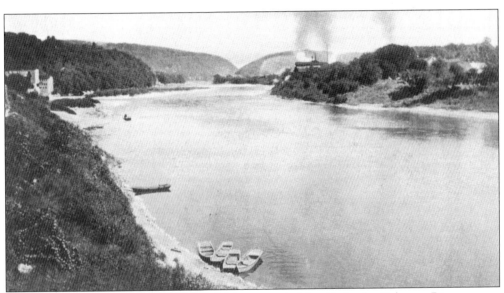

Rising from the west slope of the Catskill Mountains in New York, the Delaware River courses 280 miles on its journey to the Delaware Bay. This tranquil scene of the Delaware as it enters Easton belies its more turbulent upstream nature, especially in the area of Foul Rift. A view of the Weygadt, also know as "Little Water Gap," is seen from this vantage point above Easton. Its tributary, the Lehigh River, travels 100 miles from Wayne County, winding through the slate belt before it joins its sister river, the Delaware. Rivers were the highways of the past, and the Delaware River was one of those major routes of travel. In order to cross these channels, ferries were initially put into use. Bridges followed, spelling the demise of the ferry system. Two major canals and five railroads were later developed, making Easton a major center of transportation.

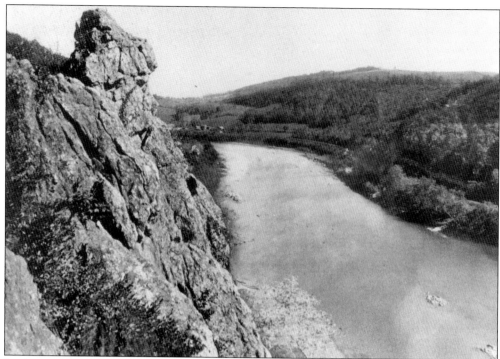

Looking north from Easton, "St. Anthony's Nose" projects from the rocky eminence overlooking the Delaware River. The interesting rock formation is located near the east end of Chestnut Hill in Forks Township.

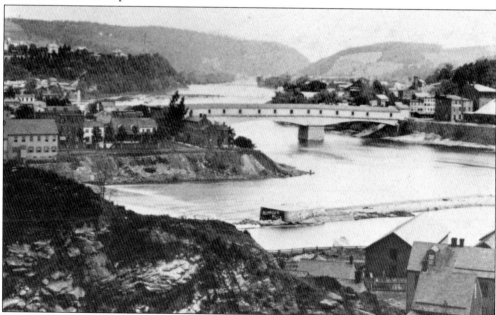

This 1880 photograph shows a view of the "the point" and the covered bridge leading from Easton to Phillipsburg. Construction of the bridge began in 1797, but took ten years to complete, due to lack of funding. Its 34-foot width provided for two footpaths and a double carriageway. Pedestrians stopped paying tolls on November 1, 1856.

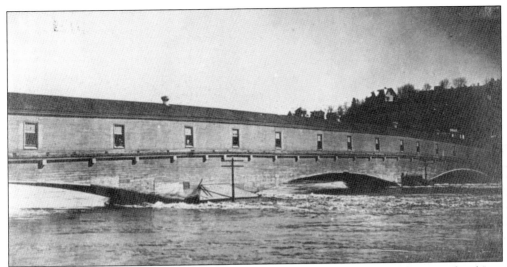

This is a view of the old covered bridge between Easton and Phillipsburg as the water level rose during the flood of 1895. The bridge was demolished shortly thereafter.

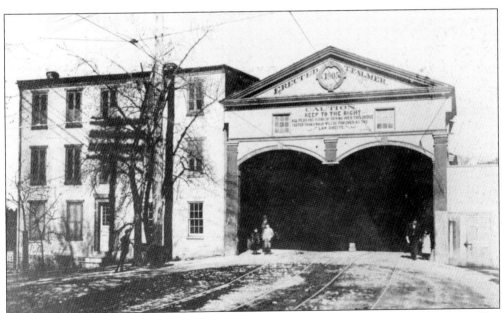

This 1892 view of the Easton entrance to the old covered bridge shows the toll collector's office on the left. The sign warned pedestrians to keep to the right and cautioned all persons riding and driving to go no faster than a walk, under penalty of law. In the winter, snow was hauled into the bridge interior and packed down so horses could pull sleighs through the bridge.

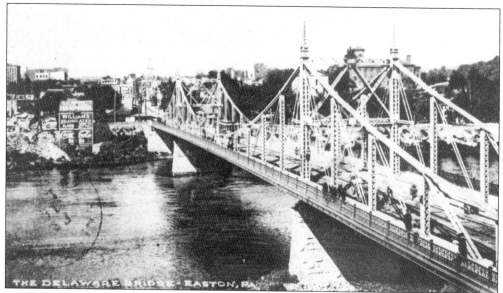

The Delaware River bridge leading from Easton to Phillipsburg, built in 1895, opened as a toll bridge until 1922, when it became the "free bridge." J. Madison Porter designed this bridge, which remained as the only road bridge crossing the Delaware until the Delaware River Joint Toll Bridge Commission built another for crossing Route 22.

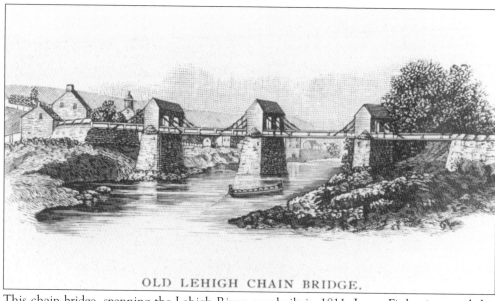

OLD LEHIGH CHAIN BRIDGE.

This chain bridge, spanning the Lehigh River, was built in 1811. James Finley invented this type of bridge, the forerunner of the suspension bridge. Its construction consisted of a level roadbed suspended from iron cables attached to wooden towers. It had a length of 423 feet and a width of 25 feet. The bridge was replaced by a wooden structure that was washed away in the flood of 1841.

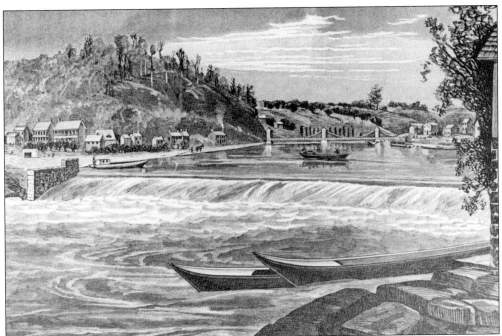

This early-1800s view of the Lehigh River shows two Durham boats in the foreground ahead of the dam and the Lehigh chain bridge of 1811. Built by Robert Durham in the 1750s, these boats played an important role in river commerce and in the Revolutionary War. Jacob Abel, of Easton, collected them to carry George Washington's troops across the Delaware River during the Christmas 1776 Battle of Trenton.

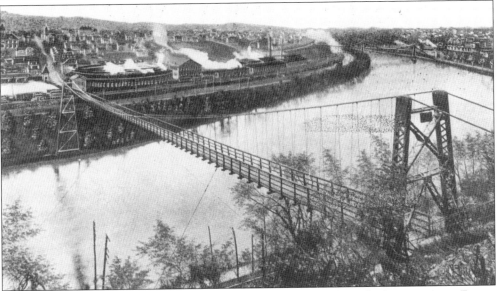

In 1884, the first of two suspension bridges were built across the Lehigh, connecting Easton to South Easton. It is believed the designer was Washington Roebling, son of the Brooklyn Bridge designer. Its nickname became the "two-cent bridge," for the amount of toll collected. It connected the Lehigh Valley Railroad station with Easton just west of Tenth Street. It was demolished in 1951.

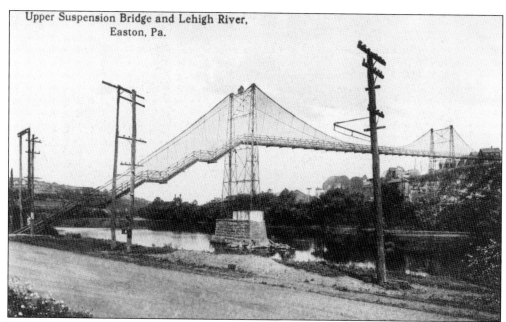

Easton's second suspension bridge, built in 1901, linked West Easton with South Easton. This also was a pedestrian bridge, called the Upper Suspension Bridge.

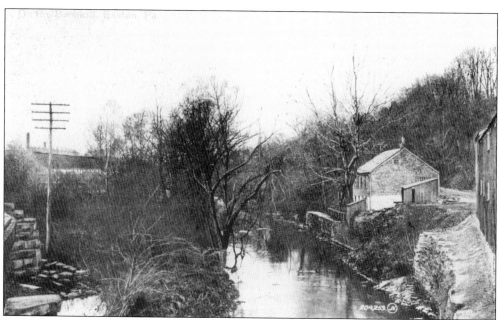

Bushkill Creek stretches 20 miles from the base of the Kittatinny Mountains, entering the Delaware just above the Lehigh River. It was known earliest as Lehichton Creek and Tatamy's Creek. Its winding course increases its power, producing a prime location for early mills.

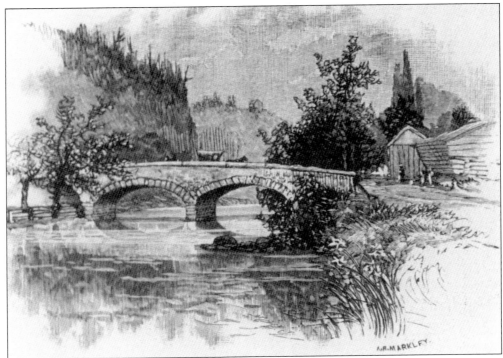

The arched stone bridge crossed the Bushkill Creek at Hamilton (now Fourth) Street and, for many years, provided the only means of passage. It was built in 1792 and replaced in 1873 by an iron structure. Visible beyond the bridge is the rear of Mount Jefferson.

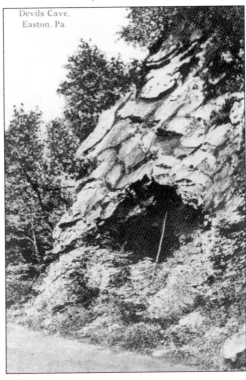

Devil's Cave, located on the Bushkill Creek at Thirteenth Street in Easton, was once a sizable cavern. Through time and tide, it has now become a minor recession in the rock.

Getter's Island is located on the Delaware River, just north of where Bushkill Creek enters the river. It is named after Charles Getter, who was hanged on October 4, 1833, for the murder of his wife. Thousands of people flocked to Easton to witness the barbaric spectacle. It was the last public execution in Pennsylvania. Another tragedy took place near the island when the steamship *Alfred Thomas* blew up.

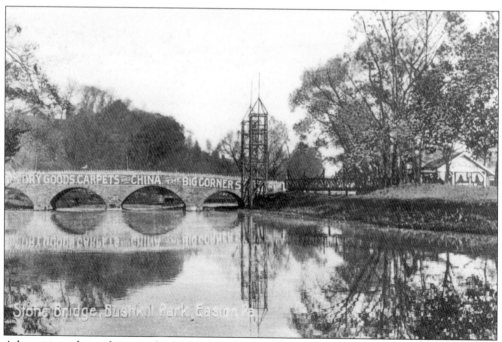

Advertising adorns the stone bridge leading to the entrance of Bushkill Park in this early-1900s scene. Bushkill Park opened in 1902. After Island Park (once located on an island in the Lehigh River) closed, Bushkill Park received some its rides, including a carousel.

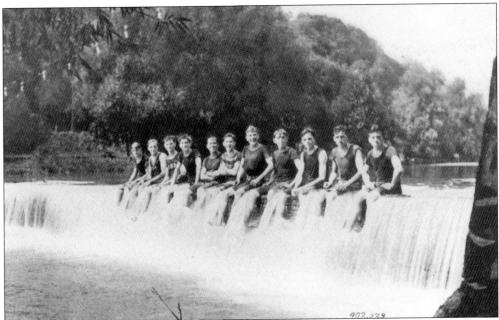

The dam at Bushkill Park provided an excellent spot for water recreation. This early-1900s photograph shows swimmers sitting neatly in a row at the dam. The dam was torn down in the 1990s.

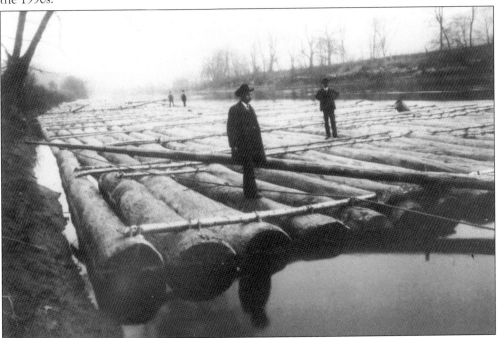

Fred Eilenberger (in the foreground) directs his timber rafting crew down the Delaware River. Usually four men navigated, with the captain situated in the middle, and the rest in the front and rear, where long oars steered the craft. Beginning in the 1740s, the rafting industry that generated in the northern Delaware River boomed from 1760 until about a century later. In the spring runoff season, about 300 rafts navigated the river.

The typical log raft measured 40 feet wide and 300 feet long. The logs were bound together with green oak crossways fastened together with honed horseshoes and soft maple saplings. Observers reported sighting timber rafts hurtling through Foul Rift, located slightly above Easton, at the speed of one mile per minute. Bridges built at Easton also presented a hazard to rafts on their way to Philadelphia.

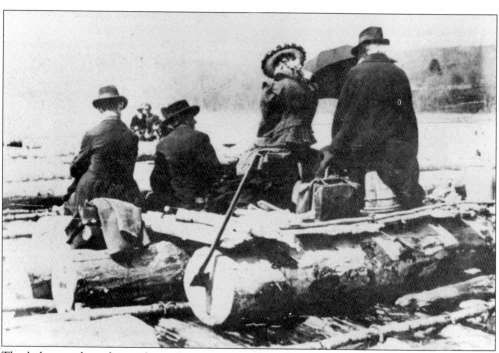

The lady seated on this timber raft presents an unusual picture. Often, passengers boarded log rafts for a brief time. Either she was one of those passengers or one of those doughty frontier ladies who labored with her husband. Her attire, however, did not lend itself to the work of logging and rafting.

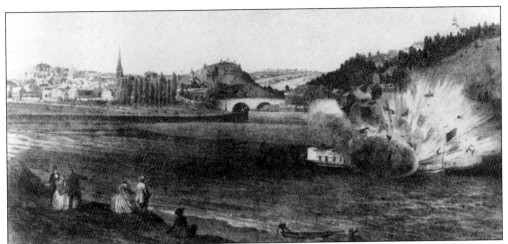

Amid much celebration and many spectators, the *Alfred Thomas* set out on March 6, 1860, on its maiden voyage to Belvedere, New Jersey. The ship, built in Easton, advanced only as far as Getter's Island when its engines and boiler blew up, causing many casualties. This view of the steamship is on display at the Easton Public Library.

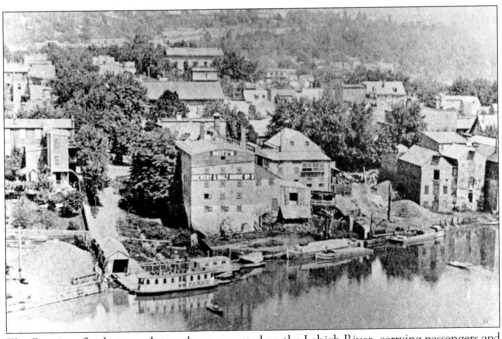

The *Fannie*, a flat-bottomed steamboat, operated on the Lehigh River, carrying passengers and freight back and forth from South Second Street to Glendon. It is shown moored near the Seitz Brewery and Malt House building.

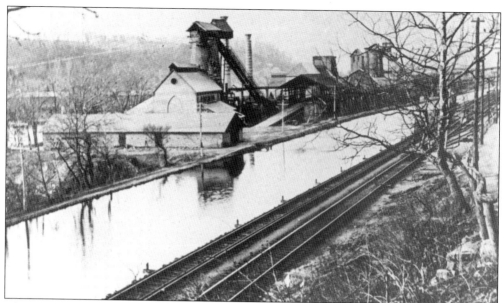

Charles Jackson Jr. opened the Glendon Iron Works at Glendon in the early 1850s. In the year 1858 alone, the company produced about 22,000 tons of pig iron and 45,000 tons of coal. It used 60 to 70 canal boats to freight iron ore, pig iron, and coal to market. Earlier in 1843, William Firestone had built the first blast furnace in Glendon, the forerunner of Glendon Iron. The iron works was discontinued shortly after the economic panic of 1873.

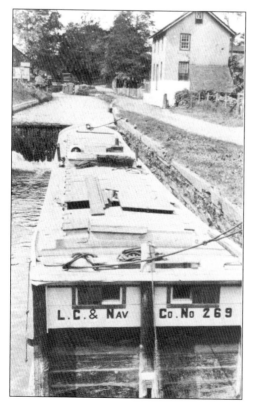

This view shows a Lehigh Coal and Navigation Company boat paused in the lock, with the locktender's building on the right. These boats carried coal down the Lehigh and Delaware canals to Bristol, Pennsylvania. They were built in two sections, with an overall length of 87.5 feet and a width of 10.5 feet.

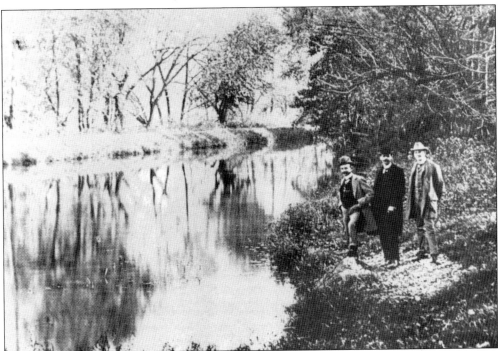

This 1899 photograph shows, from left to right, Mr. Hay, Mr. Hoffman, and Mr. Braden on the bank of the Delaware Canal just below Easton. The Easton stretch of the state-funded canal was completed in 1832. Lehigh Coal and Navigation Company acquired the canal in 1866, and operated it until the company's last canal boat made its final run on October 17, 1931.

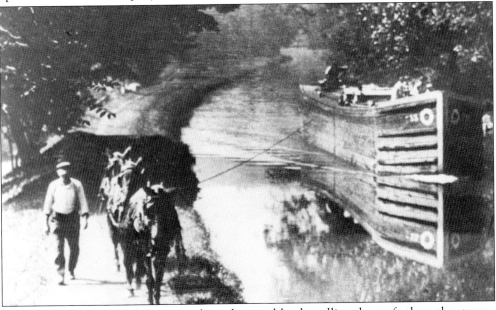

A mule driver would lead the team along the canal bank, pulling the craft along the stream. Usually, entire families would work on the boats, with children leading the mules and the wife doing domestic chores while her husband piloted the craft. Living quarters were located on the lower deck.

Tony Salatan is shown walking along the Delaware Canal, south of Easton as he narrates the New Pennsylvania Network special *Of Mules and Men*. The documentary gave a view of life in the once flourishing canal era.

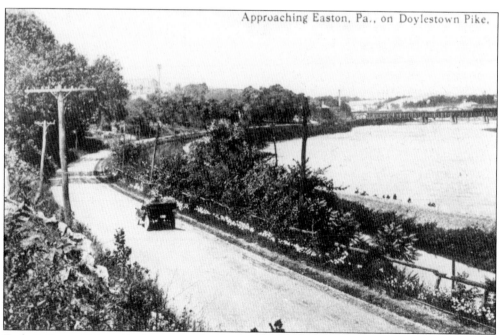

Approaching Easton, Pa., on Doylestown Pike.

Today's Route 611, earlier known as the Doylestown Pike, travels close to the Delaware River and Delaware Canal just below Easton. Since 1796, this now paved road had functioned as a major stagecoach route between Easton and Philadelphia. As stages became a lucrative business, the pike counted as a major figure in the "stagecoach wars" between stage operators.

Three

HOTELS AND INNS

This 1911 photograph shows the Jacob Bachman Hotel, the oldest existing building in Easton, which still stands on the northeast corner of Second and Northampton Streets. Constructed by Bachman in 1753, the stone tavern was the first in Northampton County to receive a license. During the French and Indian War, Benjamin Franklin attended court sessions there. George Taylor acquired the tavern in 1762. Known in the 1770s as Shannon's Tavern, the inn hosted such illustrious guests as John Adams, future president of the United States and at least two other signers of the Declaration of Independence.

After the Revolutionary War, most of Easton's hotels were concentrated in the area around Northampton and Second Streets, as these areas were close to the ferries. Most hotels had large barns and spacious grounds, but few rooms available for sleeping quarters. Many drivers with overland teams flooded the town, and space was needed for quartering horses and wagons. Wagon drivers and their assistants would often sleep under wagons. The traffic was so heavy in spring and fall that often 500 to 600 horses needed stabling. Therefore, wagoners preferred the hotels that could best accommodate their teams.

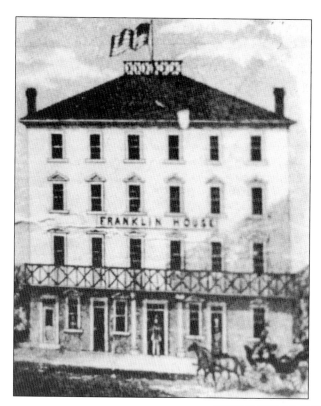

The Franklin House, pictured in 1844, was established by John Schuch and was earliest known as the Green Tree Hotel. The building was enlarged in 1828, when William Shouse became its owner. When Samuel Shouse took over in 1841, he renamed it the Franklin House. Horace Greeley, in his 1872 presidential bid, spoke from the hotel's balcony. The hotel closed in 1919, and a parking lot now takes its place at 420–428 Northampton Street.

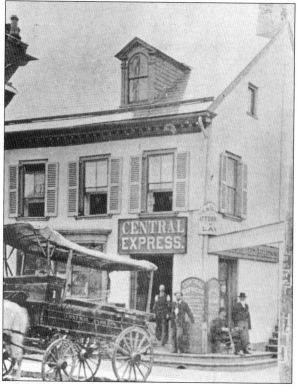

Sometime before the Revolution, a hotel stood at this location at the southeast corner of Third Street and Center Square. This 1883 picture shows the building, then utilized as an express agency known as Central Express, operated by Mr. Adams. The building was razed to make room for the Easton Trust Company, known presently as First Union Bank.

This is an 1810 view of White's Hotel, also known as the Easton Hotel, located at 60 Center Square. Owner William "Chippy" White took over a previous hotel named Everhart's Tap House, renowned for its drink called Everhart's Mead. White razed the older building and built this hotel in its place. Lafayette College was formed at a December 27, 1824 meeting at White's, and William Henry Harrison stayed here during his 1836 presidential campaign.

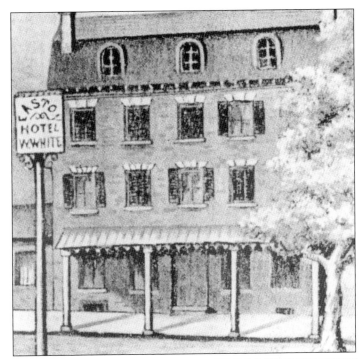

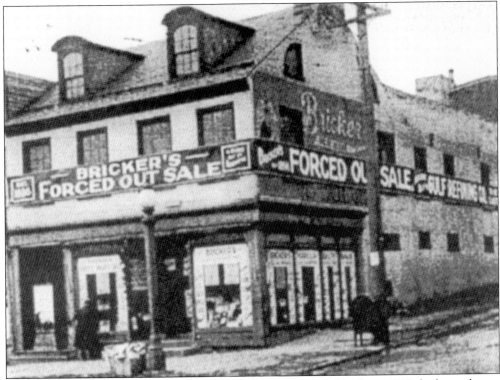

The building that once contained the Mansion House, a hotel built in 1860, had seen better days by the time this 1923 photograph was taken. Converted to Bricker's Store, it stood on the corner of Third and Lehigh Streets.

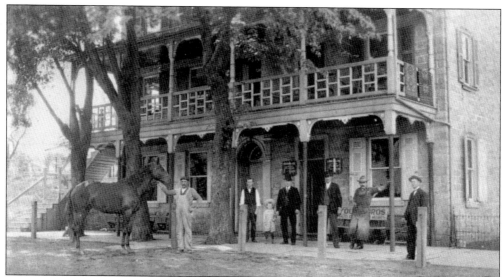

The Butztown Hotel, located outside Easton on the Bethlehem Pike, presented an important stagecoach stop between Easton and Bethlehem. It was built in 1806.

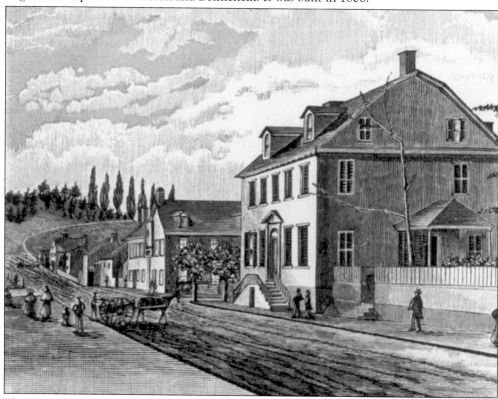

This 1836 picture, created by Elizabeth Maxwell McCartney, shows the Black Horse Hotel (left), which was later replaced by the United States Hotel, and the Sitgreaves Mansion, which became the Arlington Hotel in the 1880s. These buildings were located on North Third and Spring Garden Streets. Both of them were later razed, with Sovereign Bank taking the place of the Black Horse Hotel and the former YMCA replacing the Arlington Hotel.

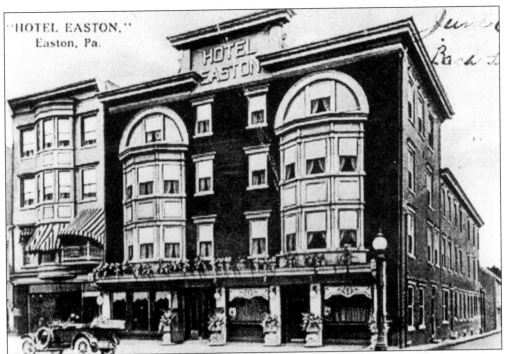

"HOTEL EASTON,"
Easton, Pa.

Hotel Easton, previously known as the Hotel for Boatmen and Raftsmen, was constructed in the 1790s by Frederick Wagner Sr. at 126–130 Northampton Street in Easton. It took on the name Hotel Easton in 1915 while under the ownership of the Williams brothers. A parking lot is now situated this site.

Mike Malarkey operated Malarkey's Hotel on the south end of the Third Street Bridge and South Delaware Drive, from 1893 to 1912. This is an 1887 view of the old hotel that discontinued operation in the 1920s.

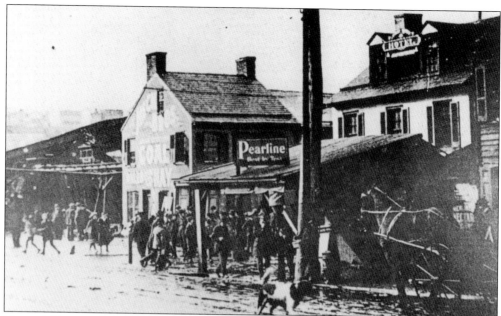

Norton's Tavern, shown after a 1902 flood mired the street, was originally called the Boatmen and Ferry Tavern and was built before 1830. Joseph Norton ran the tavern from 1894 to 1927. The Best Western Easton Motor Lodge, at Third and Washington Streets, now stands at the site of the old hotel.

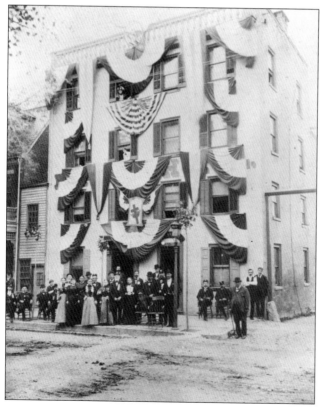

Most recently known as the Barnet House, Christopher Engel purchased the land for this hotel in 1789. Shortly after, he built the hotel, calling it the White Horse. Edward W. Barnet bought the building in 1851, and it retained his name until it was torn down in 1929 to provide room for the Lehigh Telephone Company.

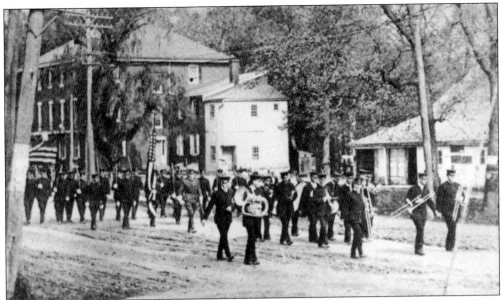

This *c.* 1914 photograph of a parade passing by on Butler Street gives a view of the Forest House at 1700 Butler Street and Forest House Stables at 1710 Butler Street. Jacob Odenwelder built this hotel in 1855 on Butler Street in Odenweldertown (now Wilson Borough). The Mirage Lounge currently occupies this site.

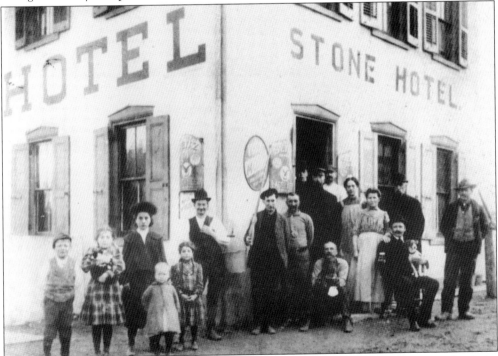

The Stone Hotel, shown *c.* 1900, is located on Main Street in Glendon, just south of the Twenty-fifth Street bridge. The building dates from the 1740s, and it is believed that it may have been used as fort for defense from Native American attacks. At one time, gun slits were built into the walls. Today, the old hotel is called the Old Stony Bar and Grill.

The American Hotel stood at the southwest corner of Third and Pine Streets. Known originally as the Golden Lamb, it is believed Conrad Ihries Sr. built it in the late 1770s. Melchior Horn Jr. took over the hotel in 1835, renaming it the American Hotel. Pres. Martin Van Buren stayed at the hotel in 1839. It was razed in the 1850s to make room for the Drake Building, which, in turn, was torn down for the Easton parking garage.

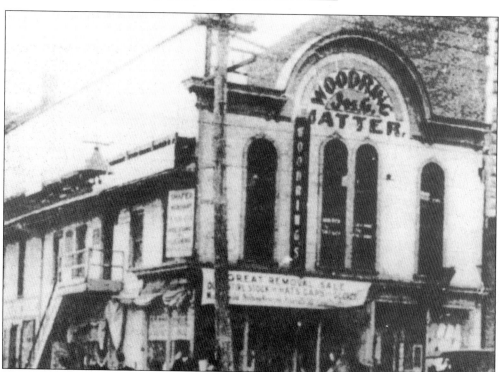

This 1906 photograph of a business at Fourth and Northampton Streets belies its early origins. Two hotels had operated at that location. In 1772, Adam Yohe Sr. purchased and razed one of Easton's oldest hotels that had been operated by Nicholas Scull in the 1750s, replacing it with one named Adam Yohe's Inn, later known as the Jackson Hotel. The building, demolished in 1908, is now the site of the Northhampton Building.

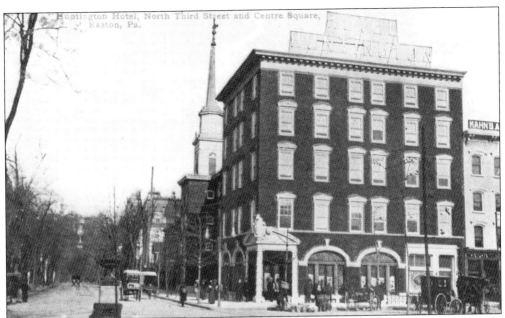

The Huntingdon Hotel is shown in 1909 on the northeastern corner of Center Square and Third Street. The Northampton Mutual Insurance Company formed it from two brick buildings—one built by Jacob Arndt Jr. in 1809, and the other in 1838. The former hotel now serves as an apartment building.

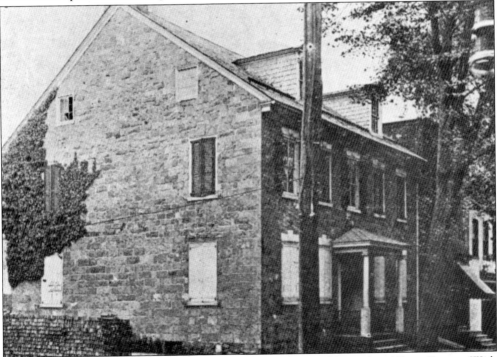

Built in 1806, the John Nicholas Hotel stood on the corner of Second and Ferry Streets. With its yard reaching to the Lehigh River and its closeness to two ferries, it made a convenient location for overland teams and drivers to stay.

The Peter Nungesser Hotel was built in 1797 on the corner of Green and Northampton Streets. At the time, Nungesser operated the Bull's Head Hotel on North Third Street and evidently planned the building as a second hotel for his son. However, it seems he changed his mind and used the building as his residence until his death. It was razed in 1927, and the Hotel Easton took its place.

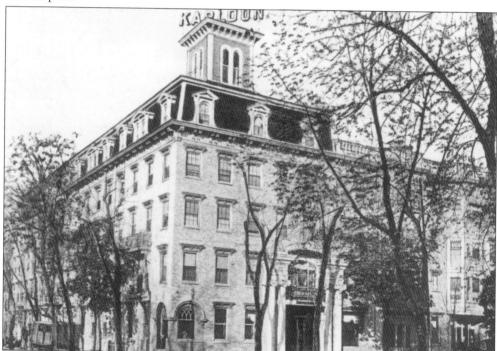

The Karldon Hotel in the early 1900s served as Easton's largest hotel. Situated on the northwest corner of Third and Spring Garden Streets, it was formerly the United States Hotel. It is now the site of the Sovereign Bank.

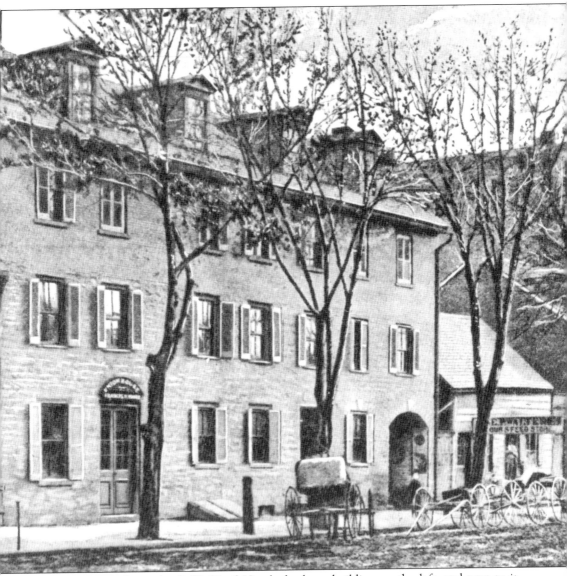

This 1885 image shows the Bull's Head Hotel, the large building on the left, and next to it, Jacob Yohe's Tap House. When the British occupied Philadelphia during the Revolutionary War, Robert Levers hid official documents and money belonging to Congress, the state, and the city of Philadelphia in this building.

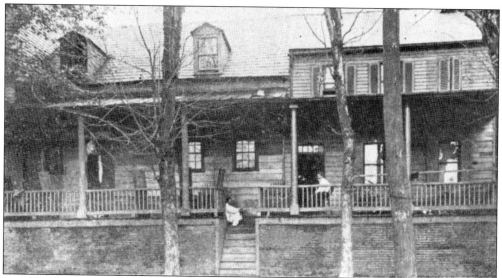

Nathaniel Vernon's Ferry House was located on the northeast corner of Front Street (now Larry Holmes Drive) and Ferry Street. Vernon purchased the property in 1755 from David Martin, who had operated a ferry there since at least 1742, although some historians place Martin's ferry as early as 1739. Many famous historical figures, such as George and Martha Washington, Gen. Horatio Gates, Gen. John Sullivan, Nathaniel Green, John Hancock, Casimer Pulaski, Ethan Allen, Baron Von Steuben, Benedict Arnold, and many others used the ferry. This 1911 picture shows the historic landmark (now torn down) in a more derelict condition than in earlier years.

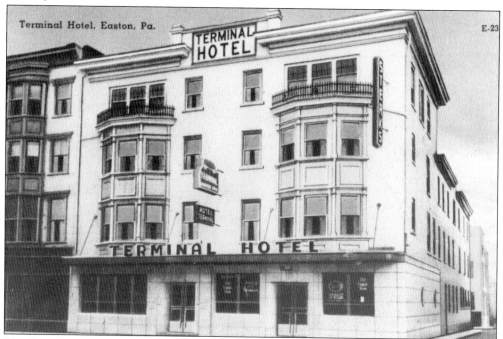

The Terminal Hotel took over the building previously known as the Hotel for Boatmen and Raftsmen and the Hotel Easton at 126–130 Northampton Street. The Williams brothers repurchased the "completely rebuilt" hotel in 1935, dubbing it the Terminal.

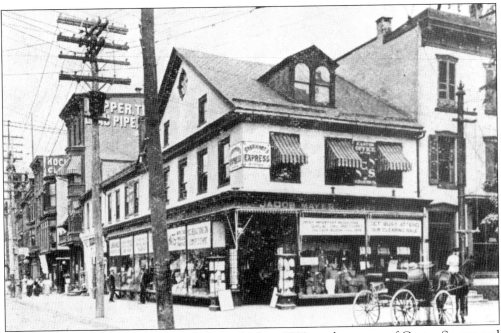

Michael Hart's Hotel, pictured in 1911, was built *c.* 1780 on the corner of Center Square and Northampton Street. Later converted to a store, it was subsequently razed to provide a location for Jacob Mayer's Clothing Store. The Carlson Wagonlit Travel Agency currently occupies the building.

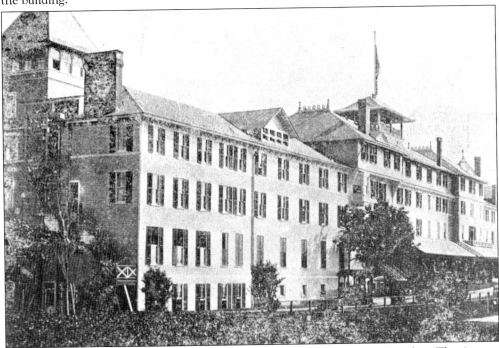

The Paxinosa Inn opened on July 3, 1888, on Chestnut Hill in Forks Township. The 4-story, 300-foot-long building had 82 guest rooms and was further enlarged in 1890. Fire destroyed the hotel on June 10, 1905.

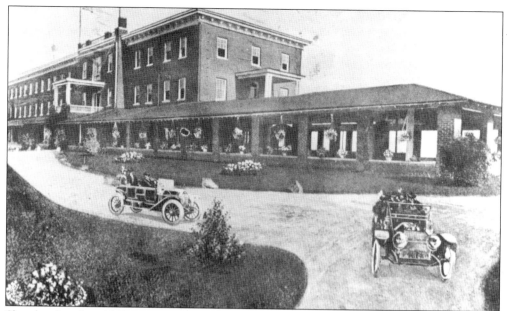

Shortly after the old Paxinosa Inn burned down, a new "fireproof" second Paxinosa Inn was built. This, too, was destroyed by fire on February 18, 1931.

The Mount Vernon Hotel, pictured in 1906, was built at 542 Northampton Street, Easton in 1855. By 1877, it was known as the Rocky Mountain Hotel, but its name was changed back to Mount Vernon. In December 1997, the hotel briefly took on the name of the Florentine for the hotel featured in the movie *The Florentine*.

Four

A CITY OF COMMERCE

On market days in Easton, the wagons circled around the square, bringing goods from outlying areas, illustrating the importance of Easton as a strategic trade center for the surrounding countryside. In 1796, a public market house was built in the open space slightly north of the courthouse. The building was subsequently razed, but sidewalk space was rented to vendors, and the tradition of outdoor marketing continued for many years. The Pennsylvania Dutch thronged to Easton on Tuesdays and Fridays to sell their wares. Easton's farmers market reigned for many years as one of the country's oldest.

In early times, the town operated largely as a grain market and shipping point, often with 15,000 to 20,000 bushels of grain being handled daily. Among the earliest industries to evolve were the granaries. The Bushkill Creek's mills ground grain from the surrounding towns in New Jersey and Pennsylvania, often from as far west as the Wyoming Valley. With the abundance of grain, distilleries and breweries cropped up. In 1833, the borough contained four distilleries, one brewery, and seven flour mills. The Industrial Revolution brought many other industries to town, primarily along the waterways.

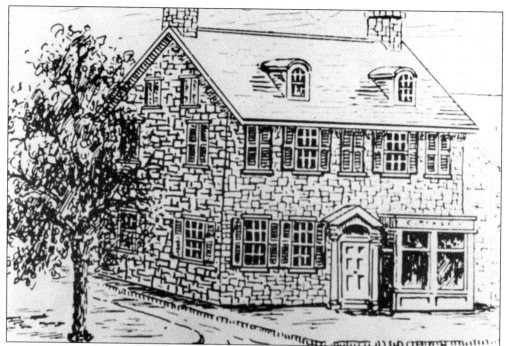

In 1787, Christian Bixler opened his jewelry store on the northeast corner of Bank and Northampton Streets in Easton. Following the Revolution, people began buying clocks rather than relying on the town crier to announce the time. Bixler supplied the need, building "grandfather clocks." Bixler's later became the oldest family-owned jewelers in America. Today, any existing clocks made by Christian Bixler command a tidy sum.

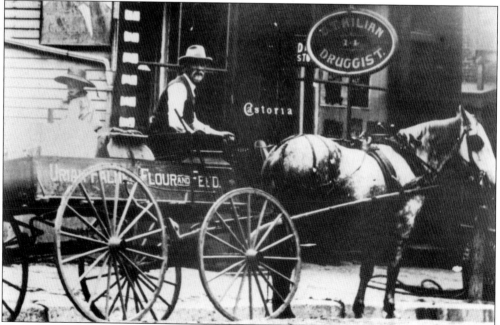

Uriah Palmer's Flour and Feed Store on 18 Center Street stands next to Killian's Drug Store in this 1894 photograph. The buildings were razed, and Canal Park townhouses stand there now.

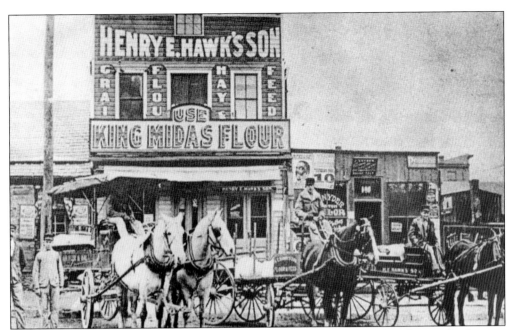

Byron J.S. Hawk, pictured on the far left, owned Hawks Flour and Feed Mill in 1908, the year of this photograph. The mill, located on South Third Street near Lehigh Street, was known as Jacob Walters Flour and Feed Store in 1906. Later, Pep Boys automotive store stood here. Currently, the Sir Speedy Printing Company, Heritage Lanes Bowling, and the Coffee and Tea Time Café are located here.

In 1923, The Easton Express newspaper company moved from its Bank Street location to its new building at 30 North Fourth Street. William Eichman and William L. Davis started the newspaper, now Northampton County's oldest daily newspaper, with its first issue printed on November 5, 1855. Following a recent merger with the Bethlehem Times, the publication is now called the *Express-Times*.

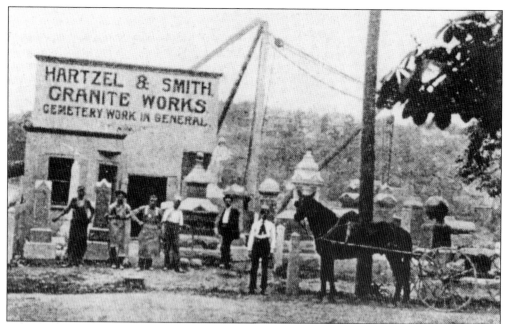

In 1892, George W. Hartzell and Benjamin Smith opened this business on Front Street (now Larry Holmes Drive) and Spring Garden Street. Hartzell and Smith made tombstones, monuments, and other cemetery items from granite and marble. The city of Easton's Riverside Park now occupies the site.

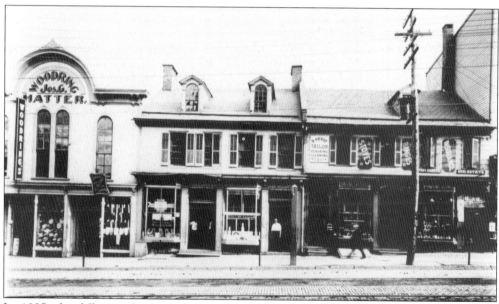

In 1905, the following businesses were located on the south side of Northampton Street at Fourth Street, as seen here from left to right: Woodring the hatter; A. Jacoby, clothier; Odenwelder's Drug Store; D. Hirst, tailor; E.B. Mack, stoves; and the real estate company. The Northampton Building and the Utopia store now occupy this location.

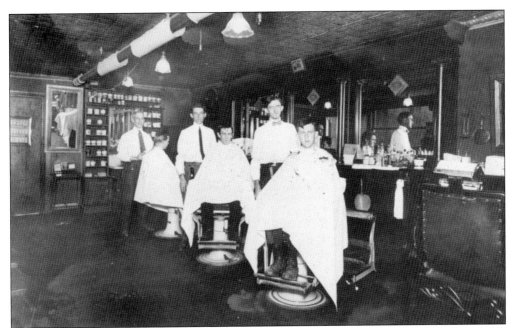

Bill Herman's barbershop operated in various locations on Center Square from 1908 to 1960, when Mr. Herman retired. In this early view, standing from left to right are barber Sam Garis, barber Charles Regal, and owner Bill Herman.

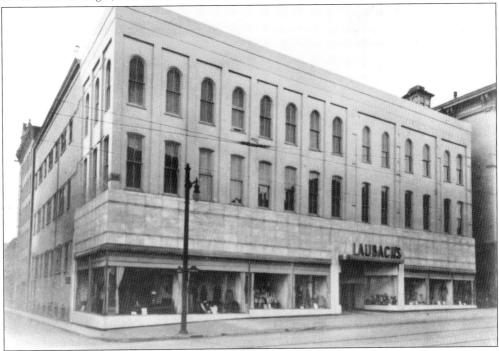

This view shows the Laubach's department store in its later days. William W. Laubach opened a dry goods store in 1860. His thriving business outgrew the building, and he launched Laubach's Trade Parlor in 1872, later to become Laubach and Son department store. Pomeroys took over the company, situated at 322–331 Northampton Street, in the 1960s and subsequently closed.

George A. Laubach, son of William Laubach, was born in Easton on October 10, 1862. His birthplace was on the site of Northampton National Bank. A Lafayette College graduate, Class of 1883, he started his business career at his father's store as an entry-level worker. George joined the business on February 1, 1889, as a partner, and the store was renamed William Laubach and Son. After his father's death in 1914, he succeeded to heading the company, then the largest department store in Easton.

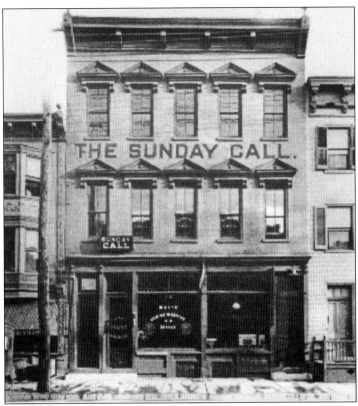

The Sunday Call, located at 318 Ferry Street, published a weekly newspaper from May 6, 1883 to May 27, 1923. Occupying the first floor were Lapp's Piano Warerooms, the White Sewing Machine office, and Diehl and Slack electrical contractors. The building was torn down in the 1960s.

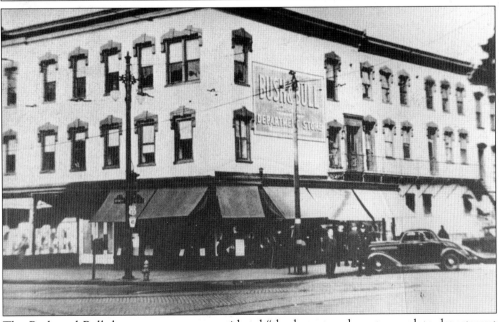

The Bush and Bull department store, considered "the largest and most complete department store in the Lehigh Valley," occupied four floors of sales space. It once occupied the building on the northwest corner of Northampton Street and Center Square. The Rite Aid pharmacy currently conducts business here.

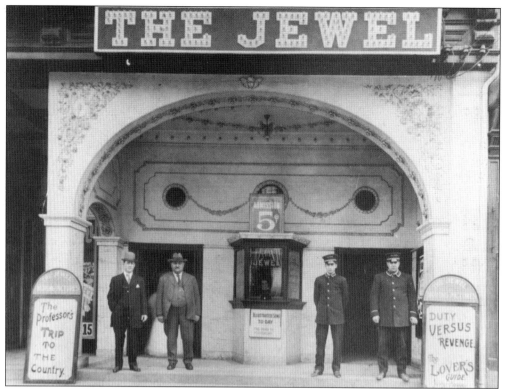

The Jewel Theatre provided one entrance to the Able Opera House, constructed on Northampton Street in 1873. The Embassy Theater later opened here. Today, the former theater building is occupied by Sigal's department store.

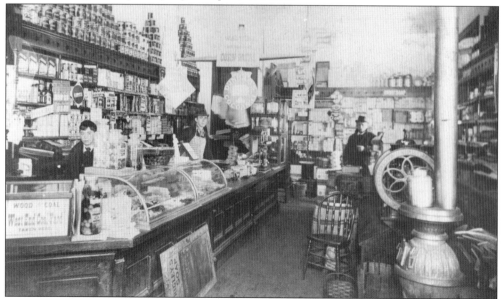

At Siegfried's Store, you could warm your chilled hands by the potbelly stove, buy yourself some penny candy, or a bag of freshly milled coffee, or even order some coal to keep your house warm. Josiah H. Siegfried operated his store at 609 Northampton Street.

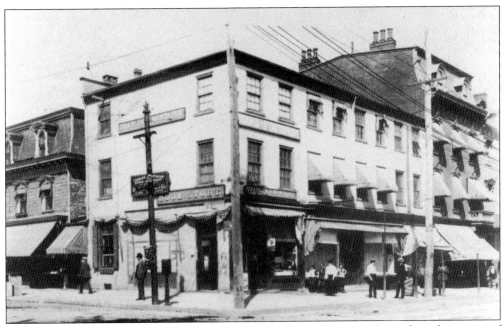

The Charles J. Montague book store, pictured September 1, 1906, was located on the corner of East Northampton Street and Center Square. The Easton Sweet Shop currently occupies this location.

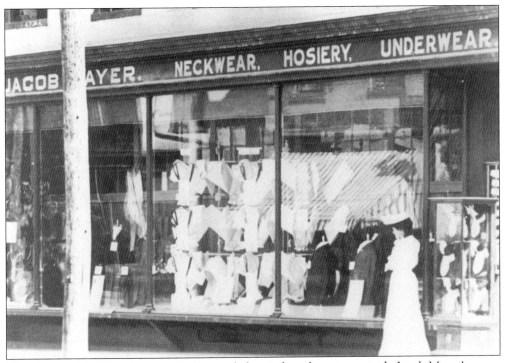

This August 15, 1906 photograph shows a lady window-shopping outside Jacob Mayer's store. Most likely she was deliberating about her husband's wardrobe or planning a gift.

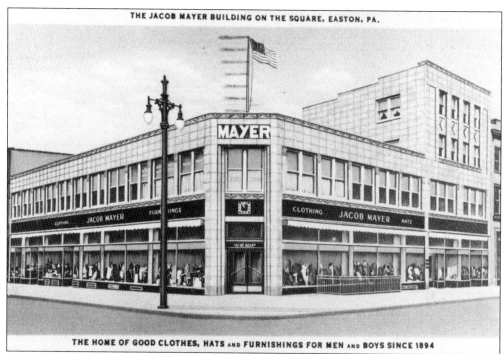

THE JACOB MAYER BUILDING ON THE SQUARE, EASTON, PA.

THE HOME OF GOOD CLOTHES, HATS AND FURNISHINGS FOR MEN AND BOYS SINCE 1894

Jacob Mayer entered the business world in the late 1800, selling clothing from a pack carried on his back. This enterprising individual worked his way to owning one of Easton's finest stores specializing in men's clothing and accessories. His store opened in 1894 as a smaller version and expanded into the large building that still stands in Center Square. It is, however, no longer a clothing store.

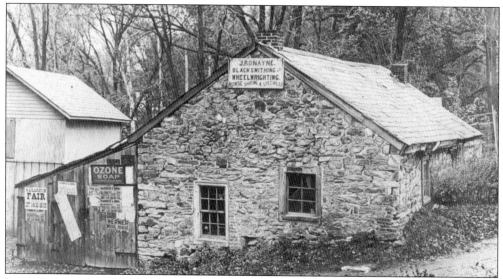

James Romayne plied his blacksmith and wheelwright trade in a building formerly constructed as an early gunsmith factory owned by Henry Young. The building was located at 940 Knox Avenue near College Hill. John Young and his brother, William Young, acted as important suppliers of guns during the Revolutionary War effort. The Young brothers operated a gun business in Easton in the mid-1800s.

56

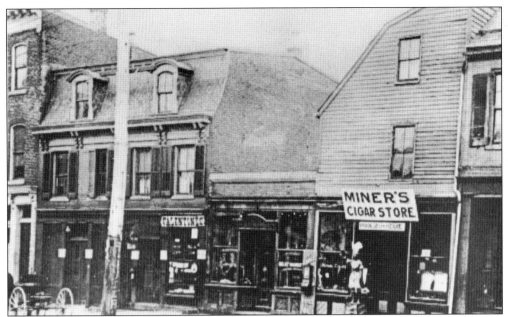

Albert Miner's cigar store, with its typical cigar store Indian, stood at 205 South Third Street in 1905. As its sign indicates, it doubled as a pool parlor.

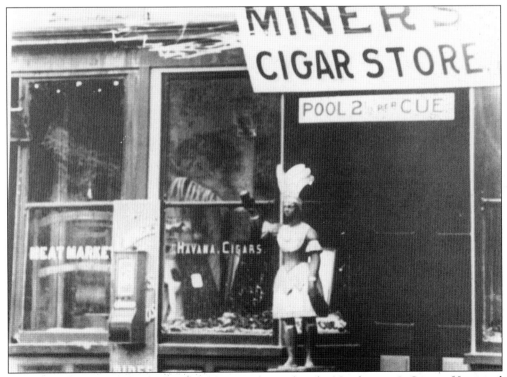

The Miner's Cigar Store wooden Indian is now located at the Northampton County Historical and Genealogical Society.

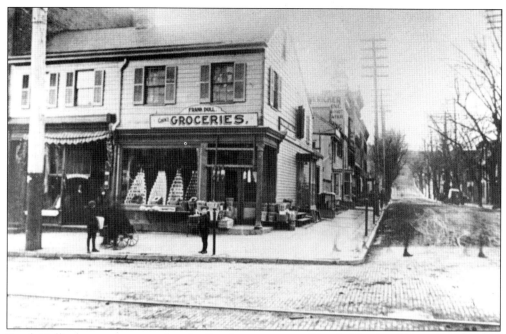

Frank Dull's grocery store stood at the Southwest corner of South Third and Ferry Streets. This photograph was taken in 1906, when the store had been in operation for at least 20 years. An 1886 directory gives the location of Frank Dull's store at 12 South Third Street.

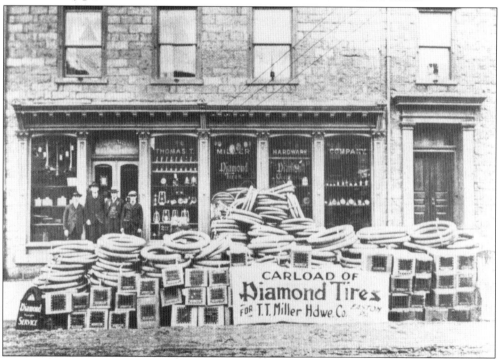

Tires galore were available at T.T. Miller's hardware store in 1915. The Easton Publishing Company, publishers of the *Easton Express*, later occupied the site of the building, then located at 30 North Fourth Street.

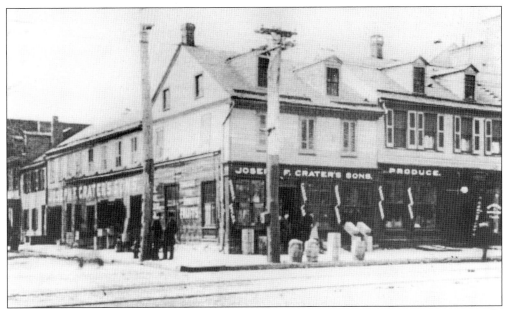

Joseph F. Crater and Sons produce market, shown in 1906, occupied the building originally built as John Arndt's residence years earlier. The Third and Ferry Street building was later razed. The Easton parking garage, which also houses the business office of the Allentown Morning Call newspaper, is located there now.

Heck's Coal Yard stood conveniently near the railroad tracks on South Third and Washington Streets. This is an 1897 view of the business that delivered its fuel until the 1940s.

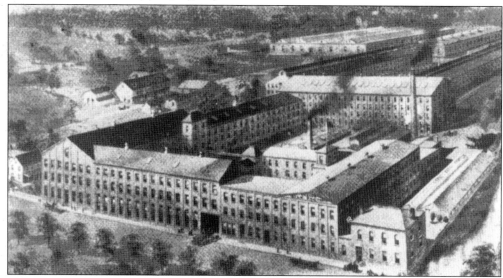

The Simon Silk Mill, established by Robert and Herman Simon in 1883, grew to a large enterprise. The mill was originally called the Easton Silk Company, which employed about 200 workers several years after it was built. By 1914, the company's worth was almost $2 million, and it was incorporated as R&H Simon Silk Company. The mill, located on Bushkill Creek, did "throwing" of silk and transferred it to other mills for weaving.

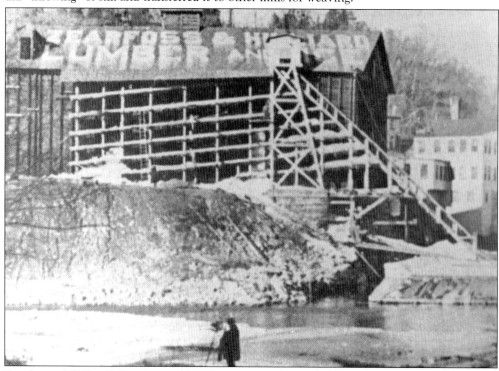

Zearfoss and Hilliard's Lumber and Ice Company was located along North Delaware Drive. The business used the wooden ramp to haul ice cut from the area of Wilson Dam into the building. In the earlier heyday of timber rafting, raftsmen preferred to stop at Zearfoss and Hilliard because of its excellent docking facilities.

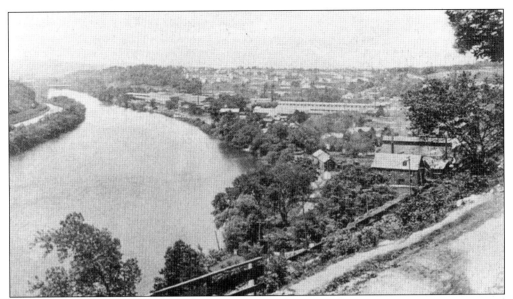

This 1897 view looking west at the Lehigh River shows the industries of Odenweldertown and the adjoining community of Mutchlertown. At one time, Odenweldertown contained a rolling mill, a knitting mill, and a railroad roundhouse. Originally settled by Johan Philip Odenwelder and Valentine Mutchler, these villages were absorbed into West Easton.

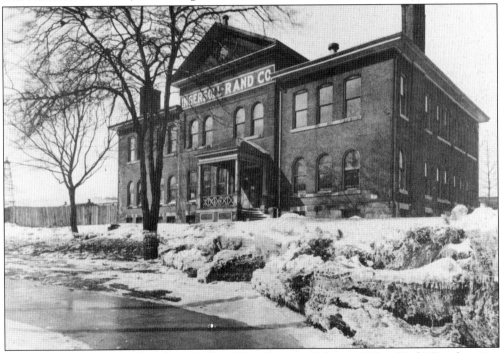

Ingersoll-Sergeant, later known as Ingersoll-Rand, moved from its New York City location to open its Easton factory in 1892. The plant became the world's largest manufacturer of compressed machinery and later opened a branch in Phillipsburg, New Jersey. The Easton plant on Lehigh Drive produced small air compressors, oil engines, vacuum pumps, calyxcore drills, and large stone channeling machines.

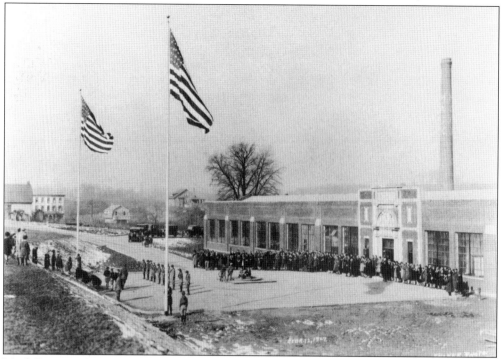

Mack Printing Company's formal dedication took place on February 12, 1926, with boy scouts raising the two flags for the ceremony. Mack flourished under the ownership of Harvey F. Mack, growing to become a publisher of the world's leading scientific magazines. Cadmus Professional Communications, a company based in Richmond, Virginia, purchased the business in April 1999.

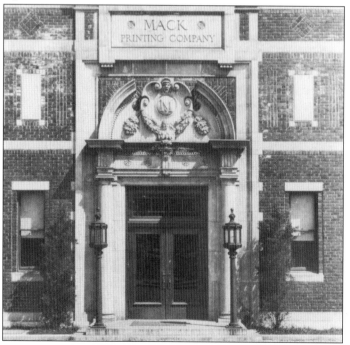

This elegant portal graced the entrance of Mack Printing with its two pilasters alongside the double doorway and decorative cornice detail. As much attention was given to its interior, with installation of skylights, improved lighting and plumbing. A sprinkler system was installed through the entire building. When the plant was enlarged, the portal was preserved as part of the office structure.

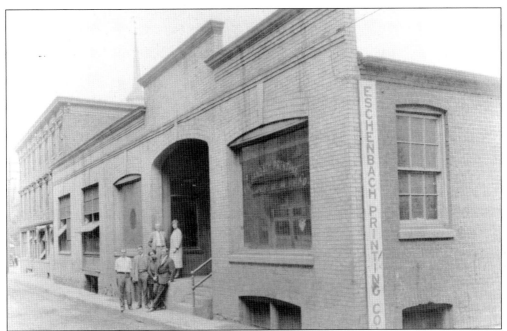

The Eschenbach Printing Company, the forerunner of Mack Printing, continued operations during construction of the new Mack Printing Plant. The employees pictured, from left to right, are as follows: (front row) Howard Stickley, Grover C. Mutchler, Wayne B. VanPelt, and Ralph W. Dodson; (back row) George O. Stout and Ester W. Morgenstern. Harvey F. Mack had previously joined the firm in 1900, when it was Chemical Publishing Company, becoming part owner.

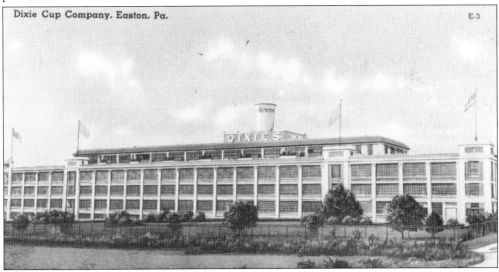

Dixie Cup Company, Easton, Pa. E-3

In the early 1900s, a growing awareness of the hazards of sharing a common drinking vessel such as a glass or "tin dipper" led to the success of paper cups. Having outgrown his New York City manufacturing quarters, Hugh Everett Moore built his factory in Easton in 1921. A later innovation of producing Dixie cups for individual servings of ice cream met with even greater success. Dixie merged with American Can Company in 1957, and in 1982 the James River Corporation acquired the American Can Company.

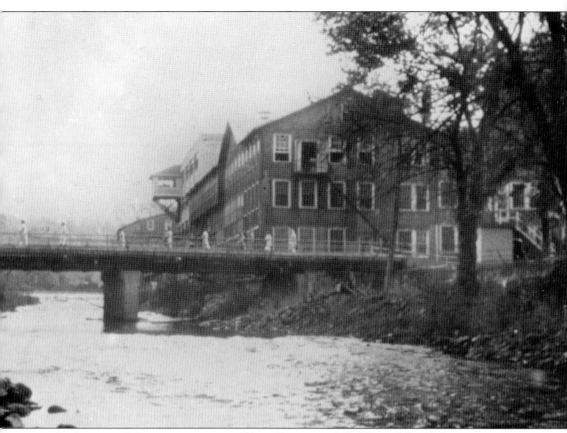

At the turn of the century, cousins Edwin Binney and C. Howard Smith began operations in this old gristmill along the Bushkill Creek in Easton. Initially, they produced talcum powder, but with the abundance of slate 10 miles up the creek, they turned to manufacturing pencils. In 1903, Binney conceived the idea of producing the now famous Crayola crayon. The Binney and Smith corporation—with headquarters in Easton and manufacturing, sales, and marketing facilities all over the world—now produces a host of educational and artistic products.

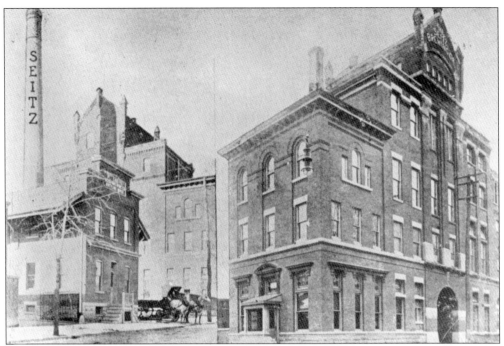

Frederick Seitz Sr. opened Seitz Brewing and Bottlers on the corner of Bushkill and Front Streets in 1821. His son, John A. Seitz, took over the company, which was connected with a Seitz family brewing and malting business on Ferry Street. The business closed during Prohibition and later became a packing house. A Greyhound bus terminal subsequently located there, and when the terminal closed, a beer distributing business took its place.

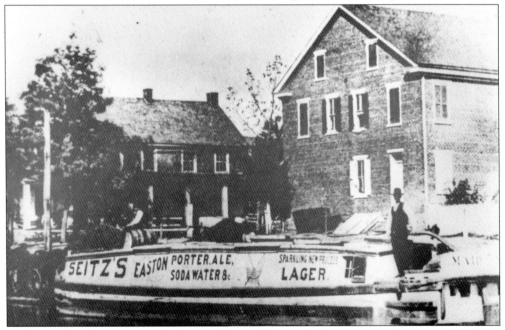

The Seitz Brewing boat traveled up and down the Lehigh River to supply customers with its lager, ale, and porter. It is pictured in Walnutport, Pennsylvania, c. 1910.

The American Flag Company, once located on Church Street in Easton kept the town well supplied with the stars and stripes. On just about every occasion, businesses draped their buildings with flags manufactured by this important industry. Looking east from Sixth and Church Streets, the company stands close to the Zion church, the tallest building on the street, which is still located there.

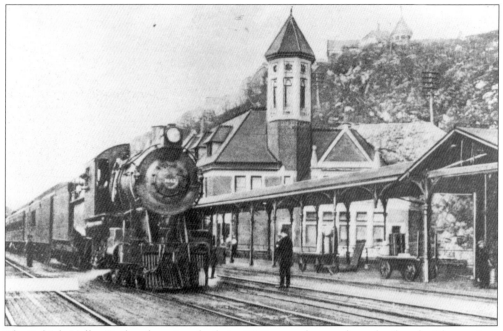

The Lehigh Valley Railroad station, built in 1890, served a number of railroads. The station, located at the junction of South Third, Canal, and Smith Streets, was demolished in 1945. This early view shows the famed Black Diamond Express train in front of the building.

Five

STREET SCENES

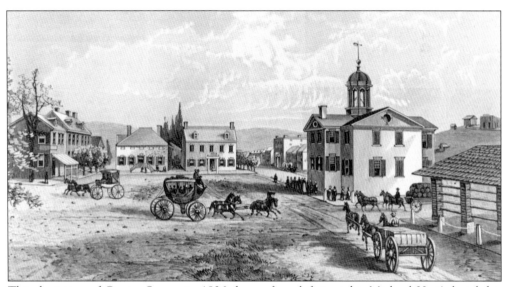

This depiction of Center Square in 1836 shows, from left to right, Michael Hart's hotel, his general store, the county offices, Pennsylvania Bank, Conrad Ihrie's hotel, the courthouse and the market house. Following the Penn tradition, Thomas Penn had donated the land for the square for rental of one red rose annually. Gradually, the streets of Easton lost their original names. At least a century later, Fermor Street changed to Second Street, Pomfret to Third, Hamilton to Fourth, and Juliana to Fifth. John Street, named for Thomas Penn's brother, was later called Sixth Street. More recently, Front Street was renamed Larry Holmes Drive. Old colonial highways succumbed to paved streets, as the town became a city. Landmarks changed in the form of progress. Buildings deteriorate or are replaced by enterprisers seeking a change. Ownership constantly shifts. Today, the city of Easton little resembles what existed centuries ago. Yet some landmarks remain the same, showing our connection to the past. The city is currently undergoing a revitalization project with a focus on preservation of the past, and of that, we are proud.

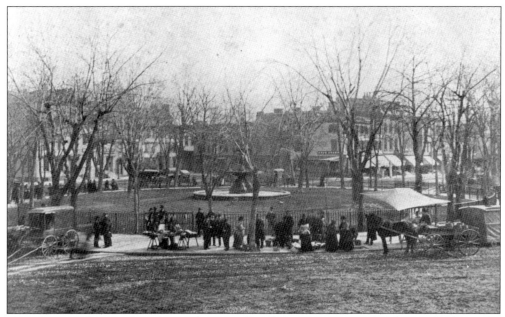

This photograph was taken during the time that the city was granted a charter. It shows the fountain that graced the center where the old courthouse had been removed. Easton was still in its "horse and buggy" days.

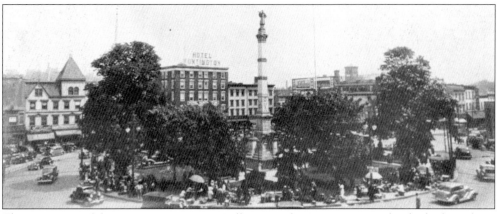

The same view of the center square in 1937 illustrates the improvements that had taken place. The tall war monument had replaced the fountain in 1900, and the Hotel Huntingdon towered above the other buildings. Easton had become a large city.

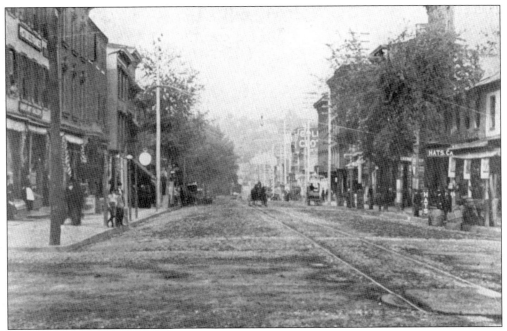

Looking down Northampton Street toward the Delaware River in 1889, one could see that "nowadays the world is lit by lightning." Poles testified to the establishment of electric lights. The Edison Illuminating Company opened its plant earlier that year at Ferry Street and made ready to deliver thousands of lights to the city. Not as obvious, telephone service now connected Easton with all prominent towns in the Lehigh Valley.

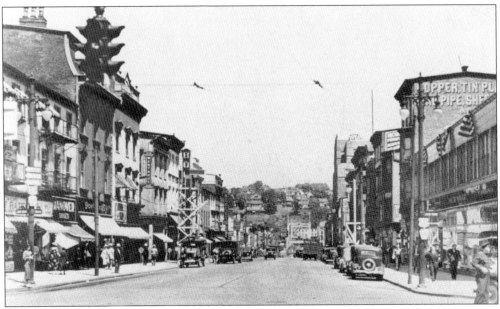

The same view of Northampton Street in 1937 shows well-paved streets. By then, the automobile had become fully entrenched, and the trolley tracks had disappeared.

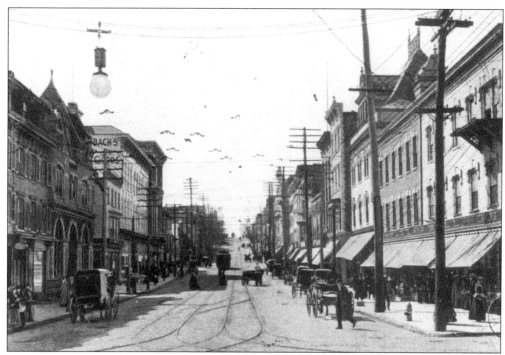

Looking west on Northampton Street in the late 1880s, this view shows the Bush and Bull department store on the right corner and Laubach's Dry Goods diagonally halfway up across the street. Trolley tracks crisscrossed the roadway.

Northampton Street. Looking West from Center Sq. Easton. Pa. E-11

Almost the same view in the 1940s shows that the Woolworth department store had taken over the Bush and Bull. The Woolworth store closed in 1978, after 50 years of business, and Rite Aid pharmacy is now located there. On the left is the Orr's clock, a landmark for years. It has been refurbished and stands today in front of Bixler's jewelry store.

This 1890 view of the southwest quadrant of Center Square shows D.W. Conklin's delivery wagon ready to deliver groceries. The building on the left was the First National Bank. Next came Edwin Haesly's hardware store and W.G. Stewart and Son dry goods, with the Easton College of Business on the second floor. Conklin's Grocers stood on the far right. Today, the Alpha Building and Bixler's jewelry store takes up this area.

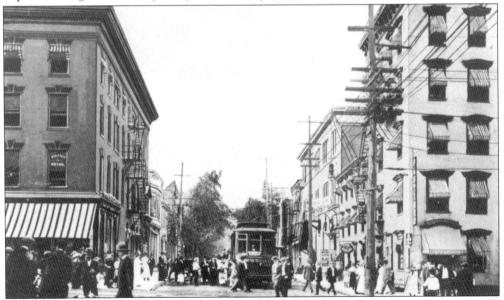

This c. 1910 view of North Fourth Street shows the Pastime Theater on the right, with C.W. Bixler's store on the left.

The first house built on North Fourteenth Street was the residence of Capt. John Hay, then considered out of town, since most construction revolved around Center Square. Built in 1871, the house was destroyed by fire on January 29, 1881.

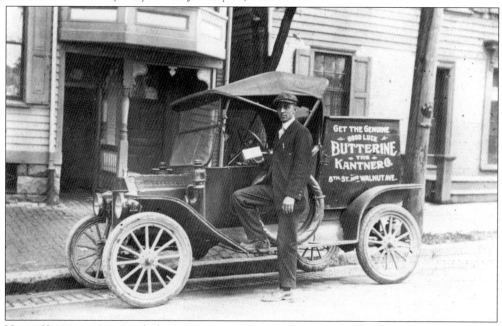

Henry Young poses jauntily by Kantner Company's delivery truck in this 1915 photograph taken on Walnut Street.

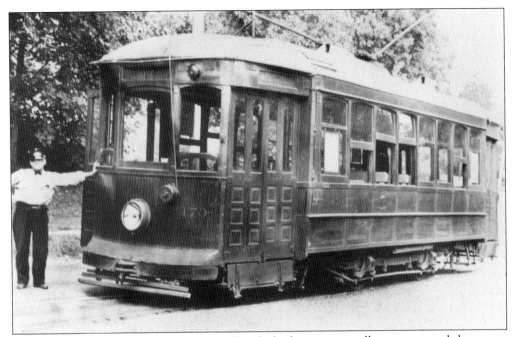

Motorman Charles H. Jones Sr. is pictured with the last transit trolley car to travel the streets of Easton. In 1887, the city was the third in the country to develop the electric streetcar system. Trolley service ended on November 5, 1939.

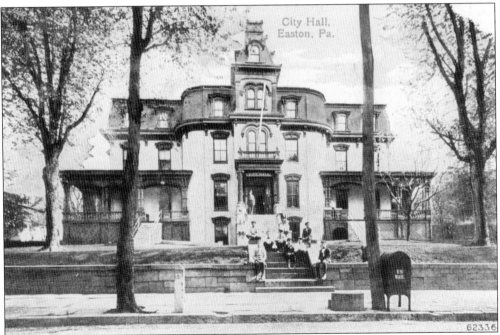

City hall, at 731 Ferry Street, occupied the former house of Judge Green, who had served as a Pennsylvania Supreme Court justice. The building was destroyed by fire in the 1930s.

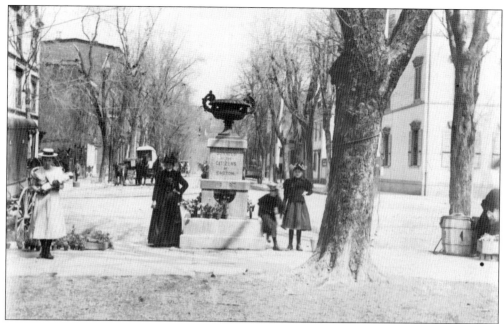

In the center of the picture is the horse tie donated by the citizens of Easton in commemoration the borough's 100th anniversary. This view looks north on North Third Street from Center Square in Easton. The women and children are unidentified in this 1887 picture.

Lafayette students and North Third Street residents did not lack opportunity for a tasty treat. These men pushing a wagonload of bananas present a familiar sight in 1904 at the bottom of the steps leading to Lafayette College.

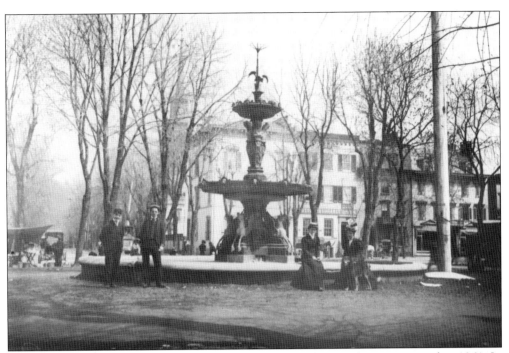

This fountain in Center Square was erected shortly after the courthouse was razed in 1861. In 1889, it was moved to Nevin Park. The people around the fountain are unidentified.

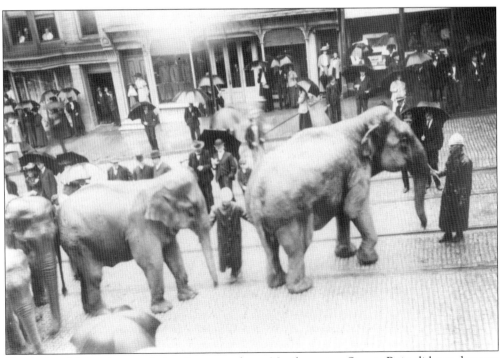

"Jumbo" and his pals attended a circus parade on Northampton Street. Rain did not dampen the spirits of parade goers who kept their umbrellas handy. This circus scene was photographed between Fifth and Sixth Streets, c. 1900.

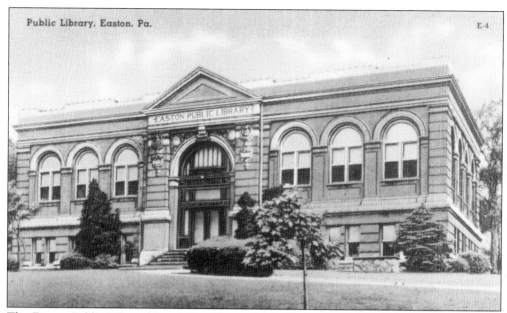

The Easton Public Library, founded on January 16, 1811, moved from its former location on North Second Street to this new building in 1903. A group of citizens donated the old burial ground on Fifth Street, and relocated graves in Easton Cemetery. The graves of William Parsons and Elizabeth "Mammy" Morgan remain on library grounds.

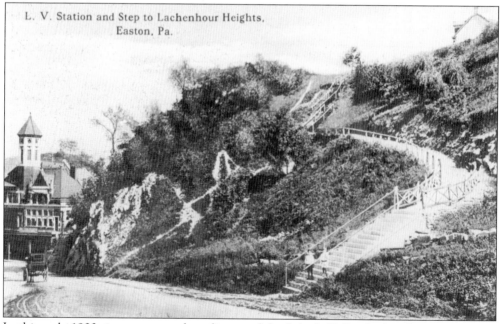

In this early-1900s image, we catch a glimpse of the Lehigh Valley Railroad station and the steps leading to Lachenour Heights. Lachenour Heights, named for Dr. Daniel Lachenour, who lived here before the Civil War, later became the site of Easton's most lavish homes.

Six

THROUGH WAR, FIRE, AND FLOOD

Teedyuscung, "King of the Delawares," was memorialized in this statue overlooking the Wissahickon in Fairmont Park near Philadelphia. He appeared prominently in the Treaties at Easton in efforts to resolve conflicts of the French and Indian War. For many years, the injustice of the Walking Purchase had festered in the minds of Lenapes, as they had gradually been uprooted. With General Braddock's defeat in 1755, the Lenapes went on the warpath. Following massacres at the Moravian Settlement of Gnadenhuetten, now Jim Thorpe, and the Minisink, messengers convinced Teedyuscung to speak at peace councils in Easton. He spoke eloquently, but was overridden by the Six Nations tribes, who had little interest in the lands of the Lenapes. The French and Indian War was the first of many crises to affect Easton, as the town provided shelter to war-ravaged settlers of outlying areas. The town played a vital role in the war for independence. Throughout these and other disasters, people helped others in their time of need, be it war, fire, or flood.

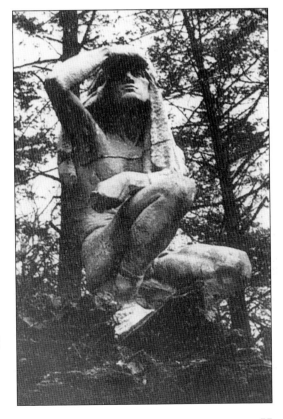

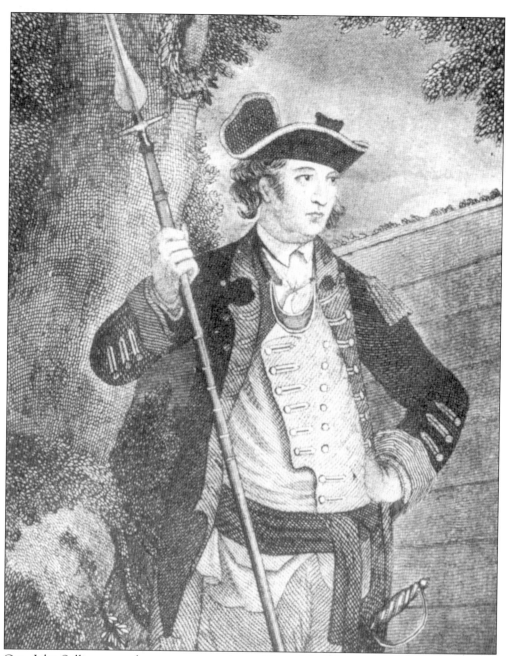

Gen. John Sullivan was chosen to avenge the uprising of the Wyoming Massacre of 1778. His army arrived in Easton in May 1779, and soldiers occupied the courthouse and the church on Pomfret Street as barracks. Soldiers were quartered in private homes and tents along the Delaware and Lehigh Rivers. The wild behavior of some soldiers was unlike any the town had ever experienced. On June 12, 1779, General Sullivan ordered the hanging of three soldiers for the murder of a tavern keeper near Stroudsburg. This was one of the most notorious hangings that took place on "Gallows Hill," a former execution site where St. Bernard's church is now located. The troops marched on to Wyoming, hacking out the wilderness on a route that is now known as Sullivan's Trail, and successfully completed their mission.

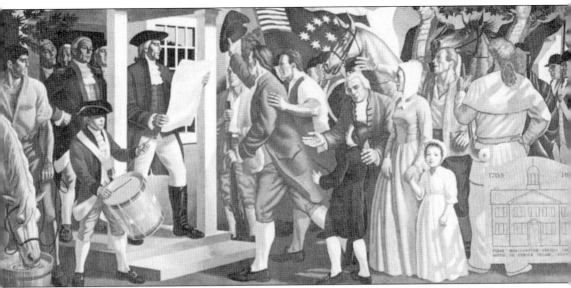

On July 8, 1776, Robert Levers read the Declaration of Independence from the old courthouse in Center Square. Easton claims the distinction of being only the third city in the United States (after Philadelphia and Boston) to have the Declaration of Independence read publicly. This mural depicting the event is located at the Northampton County government center.

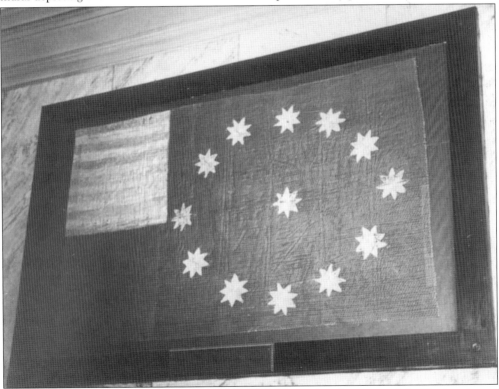

Most evidence points to this flag as the one displayed as Robert Levers read the Declaration of Independence from the steps of the courthouse. Later carried by Easton's Capt. Abraham Horn in the War of 1812, it has been in the keeping of the Easton Public Library since 1821.

Colonial warehouses at Easton provided a strategic location for supplies for the Revolutionary army. The British tried unsuccessfully for four years to capture this base, launching expeditions from New York City up the Hudson River and from the south, after their occupation of Philadelphia.

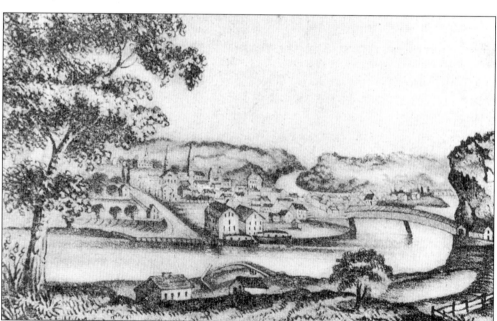

More than a dozen colonial warehouses stood at Easton on both the Delaware and Lehigh Rivers. At a later date, two still stood. This 1832 view shows Lafayette College's first home in the foreground across from the warehouses.

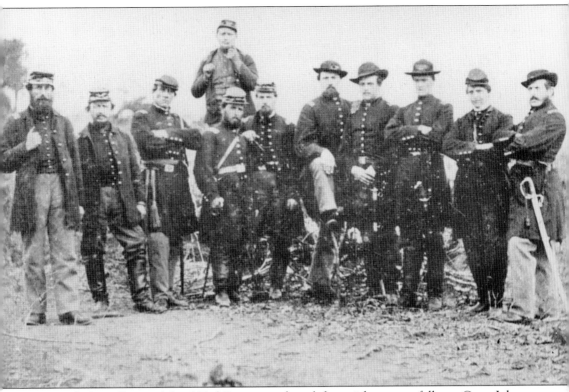

The Civil War officers of the 153rd Regiment, from left to right, are as follows: Capt. John P. Ricker; Capt. H.J. Oerter; Capt. Joseph A. Frey; 2d Lt. William Simmons; 2d Lt. William Beidelman; Capt. J.S. Myers; Lt. Henry G. Barnes; Lt. G.H. Fritchman; Lt. H.D. Yeager; Capt. H.J. Reeder; and 2d Lt. Clyde Millair. The 153rd Regiment fought at the Battle of Chancellorsville and the Battle of Gettysburg. Lieutenant Beidelman later became district attorney and was mayor of Easton in 1890. Captain Ricker died in 1906 in his Easton home in the room where he was born.

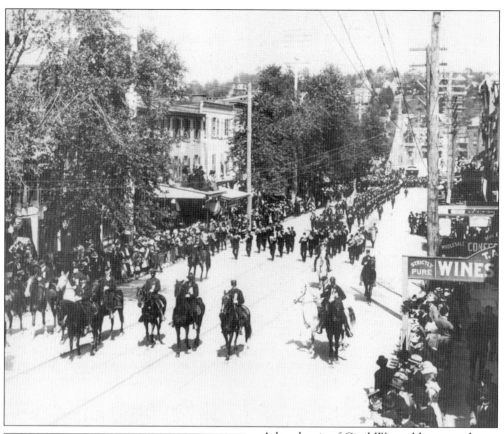

A band unit of Civil War soldiers parades west on Northampton Street on May 10, 1900. They were en route to attend the dedication of the monument in Center Square.

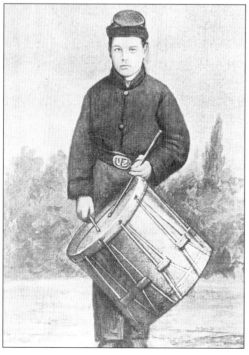

George W. Hayden, 13 years old, enlisted in Company B of the 153rd Volunteer Civil War Regiment as a drummer. As one of the youngest Easton volunteers, his service was "distinguished for prompt and soldierly discharge of duty." This picture was engraved from a photograph taken at Brooks Station in March 1863.

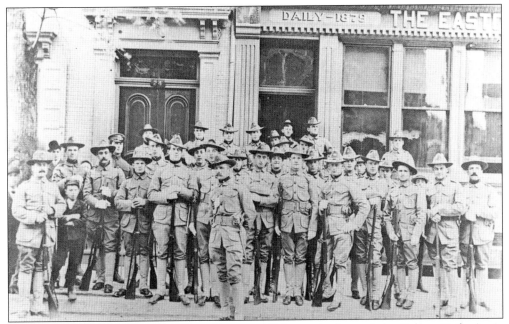

A group of Spanish-American War soldiers in 1898 pose in front of the Easton Daily Argus building on Bank Street in 1898. After the sinking of the battleship *Maine* in Cuba on February 16, 1898, Easton's recruitment office enrolled 71 soldiers from Easton and 33 from South Easton.

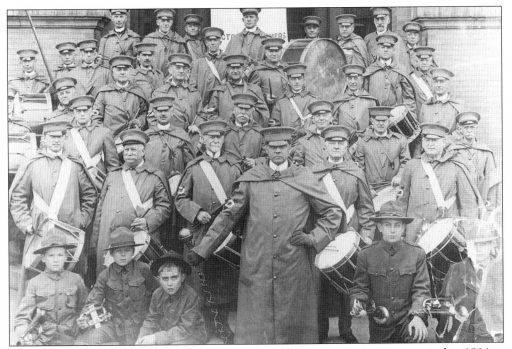

Victory drummers, shown on the steps of the Easton library, were a group organized in 1914 to see soldiers off to service in WWI. This group of Eastonians averaged 62 years of age when they established their association.

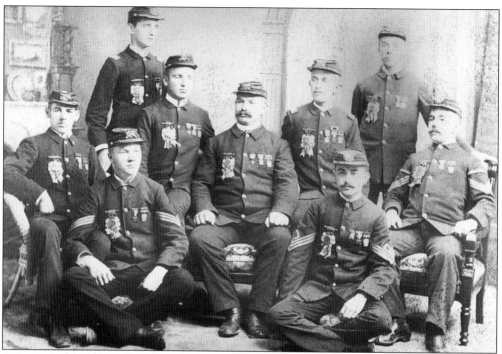

Officers of Gen. Judson Kilpatrick's Camp No. 233 organized as the Sons of Civil War Veterans, pictured near the turn of the century. The group formed in Easton in 1881.

This picture shows Easton soldiers leaving for camp in 1914. Lafayette College at the time served as a training ground, giving it the temporary name "Camp Lafayette."

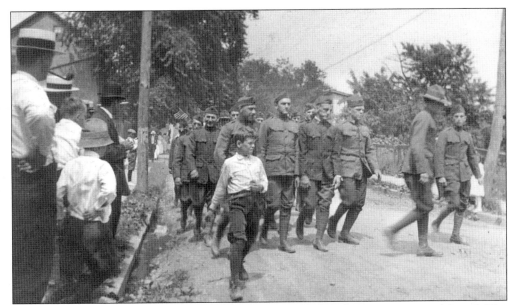

A young lad joins World War I soldiers as they informally left the scene at a parade's end. The location is believed to be West Easton.

Originally placed in Center Square soon after removal of the old courthouse, this fountain was later relocated to Nevin Park, where it is shown in this August 28, 1905 image. It was melted down as a sign of patriotism during World War II.

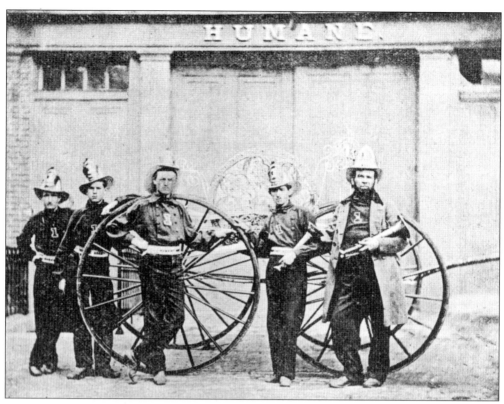

This 1870 photograph shows officers of the Humane Fire Company, Easton's first volunteer firefighters. Organized in 1797, the firehouse stood between the German Reformed church and the Sargent House on North Third Street. Pictured, from left to right, are R.C. Horn, J. Seiple, G. Mettler, R. Knauss, and G. Finley.

Phoenix Engine House claimed the distinction of being the first fire company in the Lehigh Valley to obtain a steam engine in 1856. The company was also the first to own its own horses. Organized in 1824, Phoenix Engine House was located on Ferry Street, slightly south of Sitgreaves Street.

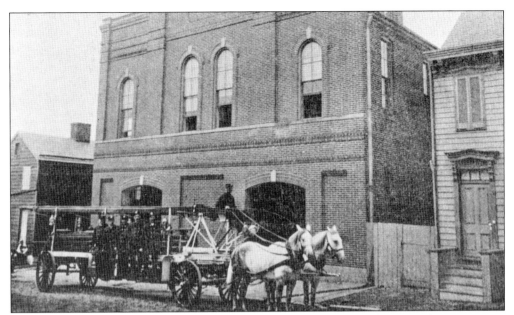

Central fire station was built in 1882. When volunteer fire departments ceased operations in 1879, Central's new paid fire department utilized four buildings of previous fire companies for a time.

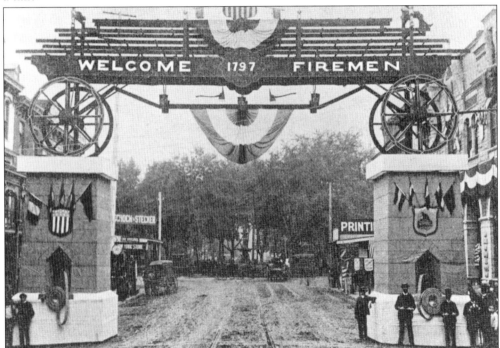

The Fireman's Arch honored the 100th anniversary of Easton's first fire company. It signified the hallmark of a parade that numbered over 1,560 participants, with fire companies from as far away as New York City in attendance. Gala celebrations followed, including a dinner at the rink, with at least 3,000 firemen and their guests attending. This September 14, 1897 pageant was the most imposing Easton had yet witnessed.

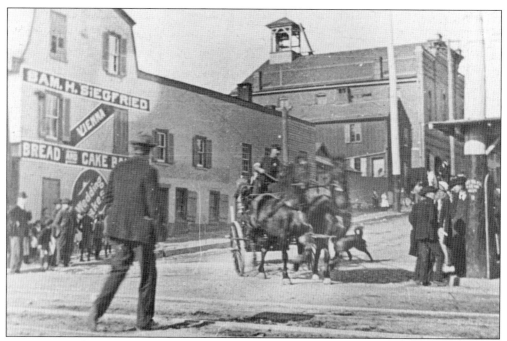

Easton's firefighters hurtle around the corner of Sixth and Northampton Streets in 1901 in their haste to put out a blaze. The dog at the rear of the fire wagon might have been the fire company's mascot.

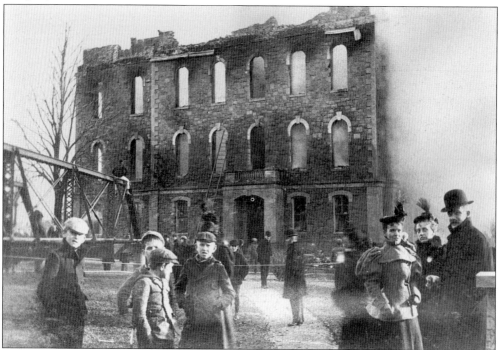

Bystanders stand dismayed after the December 1887 fire claimed Pardee Hall. A professor of moral philosophy, who was angered over his dismissal, torched the building. He allegedly had also planned to burn down other Lafayette College buildings, including South College.

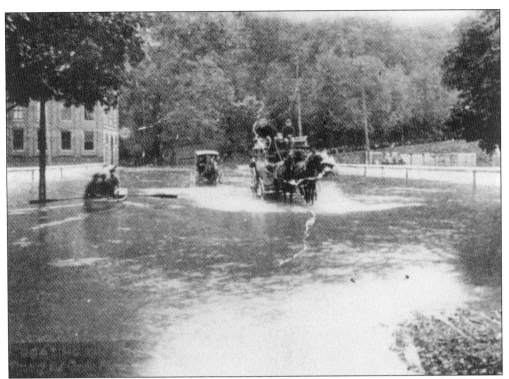

Floodwaters made crossing North Third Street difficult during the "pumpkin freshet" of 1903. This flood scene seems somewhat tranquil compared to the destruction of other areas. Elsewhere in Easton, buildings and utilities suffered great damage. The Easton-Phillipsburg Bridge remained as one of only two bridges along the entire Delaware River to survive the floodwaters.

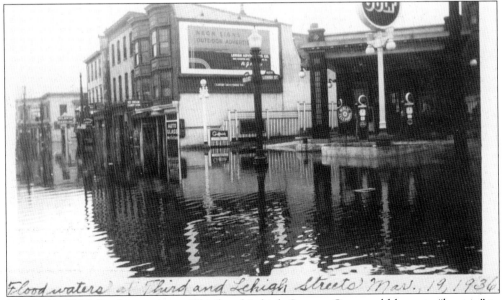

March 19, 1936 floodwaters cover Third and Lehigh Streets. One would have to "boat in" to get gas at the Gulf station on the right.

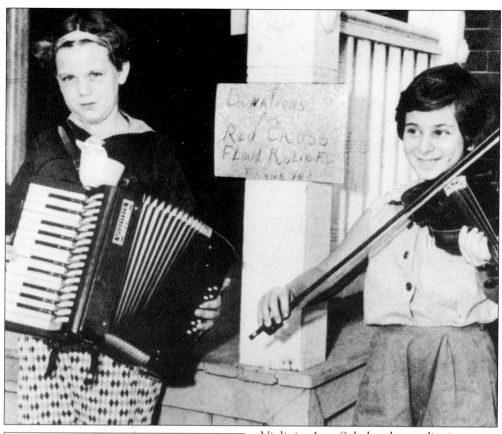

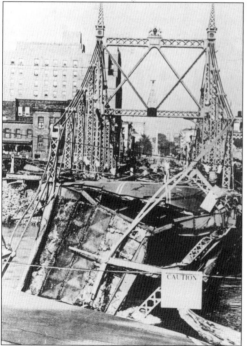

Violinist Amy Sobol and accordionist Barbara Adams entertain in a performance to raise money for victims of the 1955 flood, and their music of kindness was sweet. These young citizens of Easton seem symbolic of the many who lent time and effort to the cause. (Courtesy of the *Express-Times.*)

August 1955 floodwaters, in the wake of Hurricane Diane, tore apart a 100-foot section of the Delaware River Free Bridge. A Bailey bridge took its place until it was finally repaired in mid-1957. Diane brought about the most disastrous flood in history, smashing bridges and causing great loss of life farther north. Easton sustained about $10 million in property damages, but was spared the great number of human casualties suffered in the northern counties. (Courtesy of the *Express-Times.*)

Seven

SCHOOL DAYS

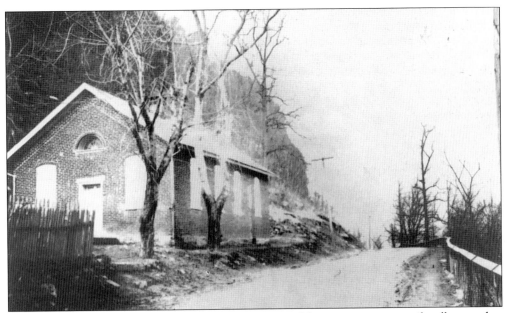

Chief Tatamy School, as it appeared in 1906, was one of the many one-room schoolhouses that dotted the area. Named for the Lenape chief Moses Tatamy, the building still stands on North Delaware Drive in Forks Township, now converted to a private residence. In early America, church schools appeared first, open only to the faith that sponsored them. "Neighborhood schools" developed later, with buildings and teachers' salaries funded by community donations, but they were available only to those whose parents paid tuition. The Free School Act, passed in 1834, provided for free public schools for all. Most free schools started as one-room schoolhouses, furnished with plain wooden benches and a wood stove and lacking blackboards, pencils, and maps. Children wrote on slates, and one teacher taught all grades in subjects of reading, writing, and arithmetic. Later legislation brought about high schools as we know them today.

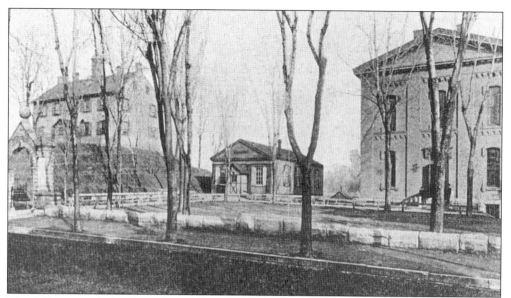

This 1874 view of schools at the corner of North Second and Church Streets shows the Easton Union Academy, built in 1794, on the far left. It was torn down in 1893. The center building composed the Female Seminary, built in 1851 and razed in 1894. On the right, the McCartney School, erected in 1856, as Easton High School still stands. The Wolf Building, built in 1893 as Easton's second high school took the place of the academy and seminary. It is currently part of the Northampton County government center.

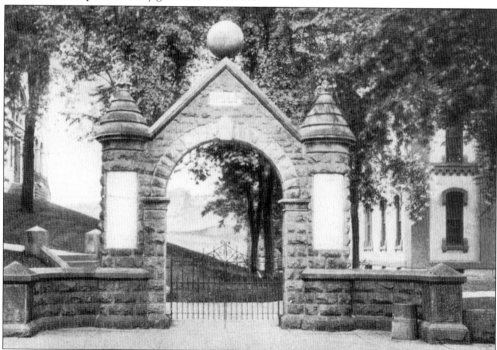

Wolf Memorial Gate, dedicated on September 28, 1888, was brought about by Easton students establishing a "penny fund" to honor Governor Wolf's great contribution to education. The archway was built of granite with copings and cappings of sandstone.

Gov. George Wolf, who served as the seventh Pennsylvania governor from 1829 to 1835, established the Free School Act in Pennsylvania in 1834. His founding of the public school system is considered among his most notable achievements. He entered the legal profession in Easton in 1799. In 1802, he became Easton's postmaster. He served as clerk of the Orphan's Court of Northampton County from 1803 to 1809. After a term in the state House of Representatives, he advanced to the Eighteenth Congress, where he remained until elected as governor.

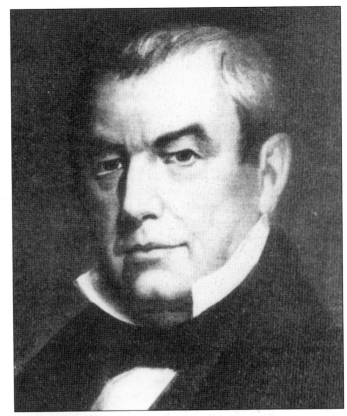

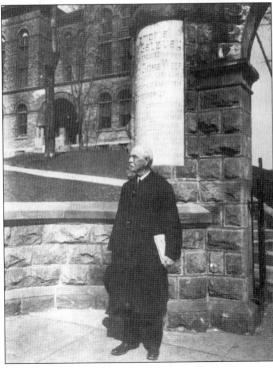

Prof. William White Cottingham held a record time as superintendent of schools in Easton, serving from 1863 to 1912. He is pictured in 1907 at the Wolf Memorial Gate in front of Easton High School on North Second Street in Easton.

93

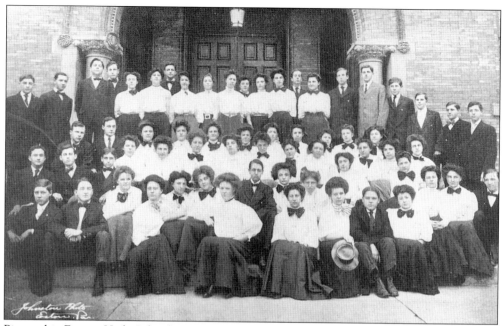

Pictured is Easton High School's 1907 graduating class on the steps of the old Easton High School on North Second Street.

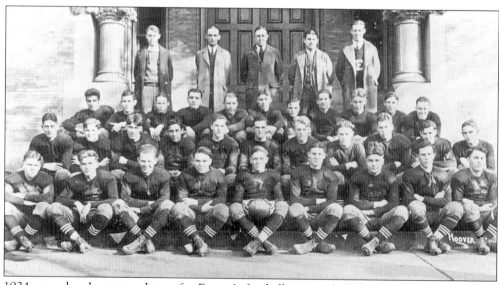

1924 proved to be a record year for Easton's football team, which led all Pennsylvania high schools in number of points scored, a total of 420 points in nine games. Under the skillful training of coach Pat Reilly (seen at top, standing third from left), the team won the state championship. Team captain Earle Ashton, is pictured in the front row, holding the football.

94

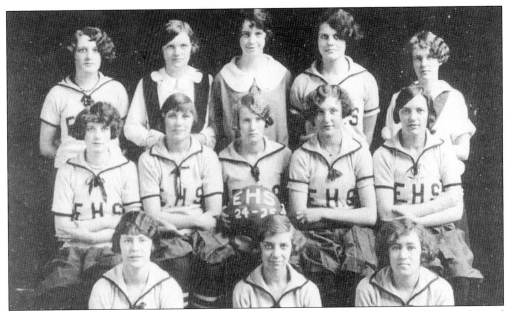

Not to be outdone by the boys, Easton High School's 1924–1925 girls' basketball team claimed a record year, winning the Lehigh Valley Girl's Basketball League championship. Shown, from left to right, are the following: (front row) Misses Kelly, Sterner, and Ostroff; (middle row) Misses Black and Gebhart, captain Josephine Bryan, and Misses Lehecka and Collins; (back row) Miss. Walters, coach Ashton, manager Morrow, and Misses Chidsey and Zeller.

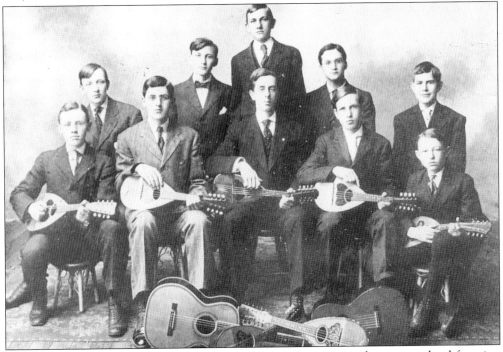

Easton High School's Mandolin Club, pictured in 1907, entertained at every school function and "never failed to receive an encore." Harry Beadell (first row, third from left) served as the group's leader. The club was founded in 1903.

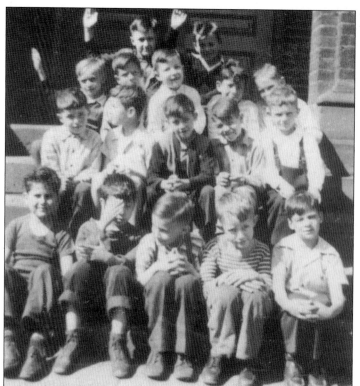

First-grade students are pictured at the Centennial School in the 1944–1945 school year. Shown, from left to right, are the following students: (first row) Richard Ebstein, Tom Todaro, Bill Horn, Tom Biblehimer, and David Mazzie; (second row) Art Minksy, three unidentified students, and Ed McNeal; (third row) Woody Frankenfield, George Kelly, Jerry Colver, Angelo Curcio, and an unidentified student; (fourth row) two unidentified students.

Lafayette College originated in this two-story building on Canal Street in South Easton. College trustees leased the farm of Christopher Medler, and classes began on May 9, 1832. Students worked in the fields and shops as part of the Manual Labor System instituted by Pres. George Junkin.

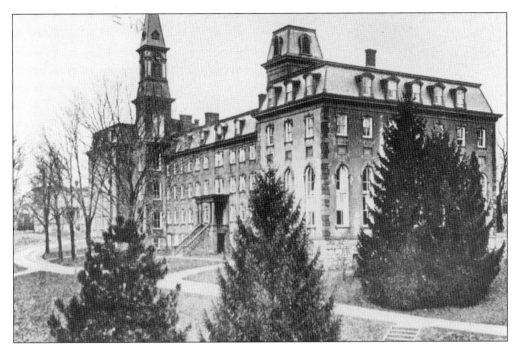

Lafayette trustees purchased a 9-acre plot of land for a permanent college location. Construction began in 1833 on this building, later called South College. By the time this *c.* 1905 photograph was taken, wings had been added to the original structure.

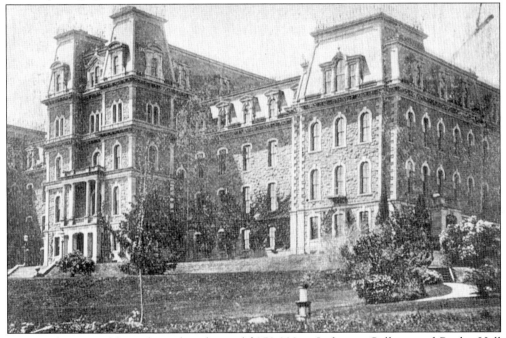

Ario Pardee, a wealthy industrialist, donated $250,000 to Lafayette College, and Pardee Hall was completed in 1873, the largest college science building in the United States. The building, destroyed in 1879, was rebuilt, and the second Pardee Hall, which burned down in 1897, was also rebuilt.

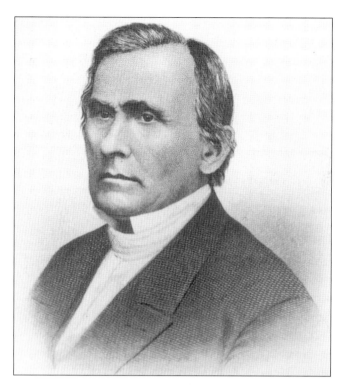

Rev. George Junkin, Lafayette College's first president, served the college from its founding in 1832 until 1841, when he resigned to accept a position as president of Miami University in Ohio. Recalled to Lafayette in 1844, he remained as president for four more years.

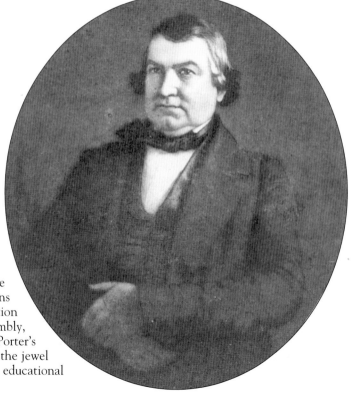

James Madison Porter, founder of Lafayette College, called a meeting in 1824 at White's Hotel to discuss establishing a college at Easton. Easton citizens immediately drew up a petition to the Pennsylvania Assembly, but six years passed until Porter's dream of Lafayette College, the jewel in the crown in Easton's educational system, became a reality.

Eight

THE HEALING ARTS

Henry Detweiler, M.D., set up practice in Easton in 1852. Born on December 15, 1795 in Switzerland, he was the oldest homeopathic surgeon in the United States when he died in 1887. Dr. Detweiler's home stood on the northwest corner of Center Square and North Third Street. He was not Easton's first doctor; that distinction belonged to Dr. Frederick Rieger, who practiced as early as 1753. Early medical practitioners worked under crude conditions, without benefit of the developments of modern medicine. The bleeding of patients was a common practice, with doctors believing it would cleanse the body of impurities that caused illnesses. Surgery was performed in patients' homes, often on the kitchen table. If instruments were sterilized at all, the kitchen range served the purpose for boiling them. Ether was not always available for surgery, so "home brew" or whiskey from the local tavern served as anesthesia. Laudanum, an opium derivative commonly used to relieve pain, often caused an addiction problem. Doctors were "a law unto themselves" and were not governed by any rules until 1877 legislation required them to be licensed graduates of approved medical schools.

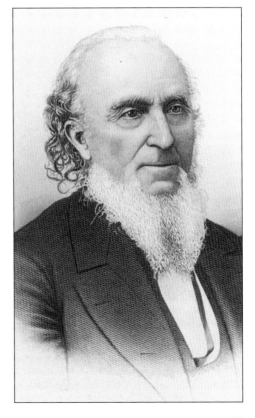

Dr. Traill Green, born in Easton in 1813, was one of the founders of the American Academy of Medicine. In 1872, became the academy's first president. He served Easton Hospital as consulting physician and also taught chemistry at Lafayette College.
Dr. Green championed the role of women in the medical field at a time when this was not a popular cause.

Easton Hospital can trace its origin to 1890, when fundraisers purchased the John Brown residence on Wolf Street. A group of Lutheran sisters, headed by Marie Sowa, operated the hospital. The hospital provided eleven beds for patients.

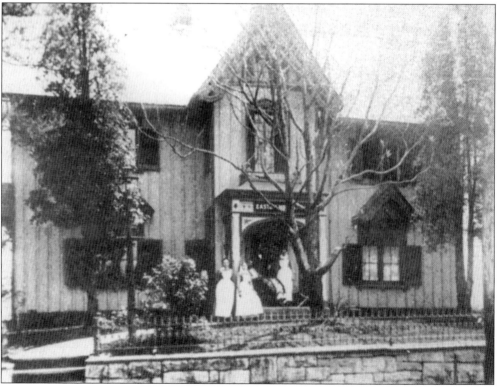

Sister Marie Sowa, a Lutheran deaconess, served as superintendent of the old hospital from 1897 to 1908. Marie and her fellow sisters received no salary for their services. In addition to her other duties, she was also the director of the Training School for Nurses.

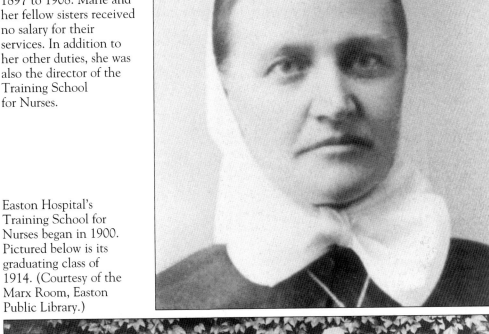

Easton Hospital's Training School for Nurses began in 1900. Pictured below is its graduating class of 1914. (Courtesy of the Marx Room, Easton Public Library.)

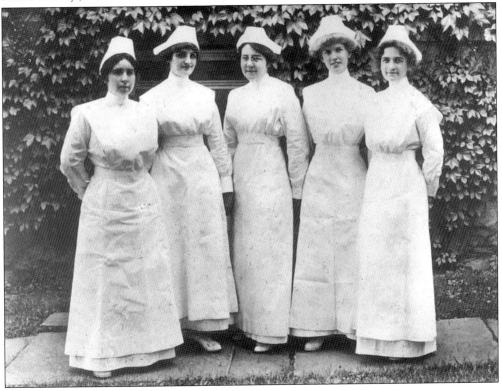

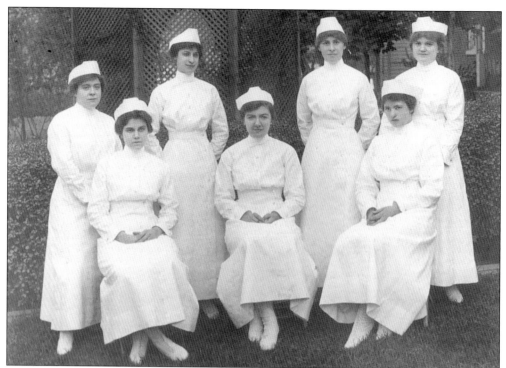

This early-1900s photograph shows the dedicated staff nurses of the old Easton Hospital on Wolf Street. (Courtesy of the Marx Room, Easton Public Library.)

In 1901, two brick buildings opened opposite the hospital for the nurses' residences, since they wanted a home separate from the hospital. The hospital and residence buildings were located on Wolf Street, south of the present Northampton County courthouse.

By 1906, increasing patient use led to replacement of the original wooden building. In the preceding year, a total of 592 inpatients and 750 outpatients had been treated. A more modern brick structure replaced the old hospital.

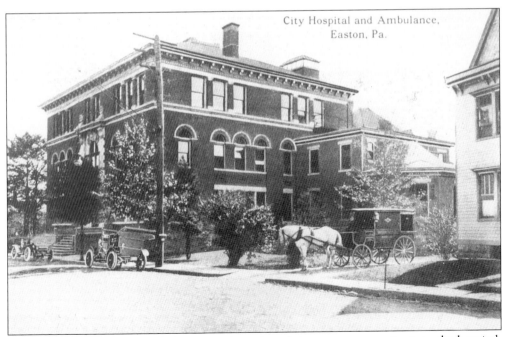

In 1910, the horse-drawn ambulance stands ready to bring emergency patients to the hospital. There were no sirens or flashing lights then, just the steady sound of hoof beats as "Dobbin" attended to his mission of mercy.

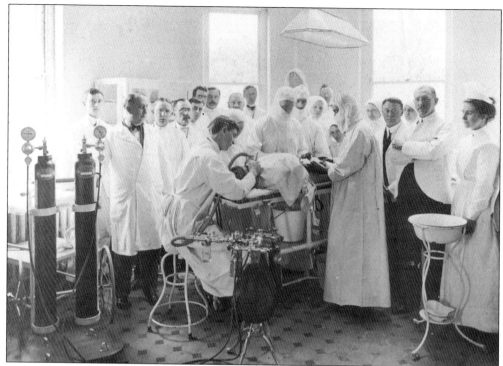

This rare picture, taken on May 14, 1912, shows an anesthesia demonstration at Easton Hospital. Anesthetist A.H. Smith of Cleveland, Ohio, gave the demonstration to the surgical clinic. Among the participants were surgeons Thomas Zulick and Henry D. Michler.

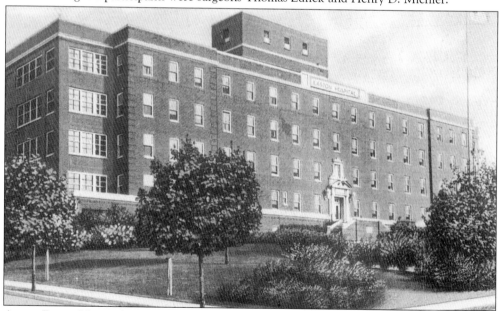

A new Easton Hospital opened in 1930 at 20–22 Lehigh Street. The land had been purchased 15 years earlier with the help of fundraising events and private donations, but WWI and administrative problems had intervened. The new nurses' home was also dedicated at the opening of the new hospital.

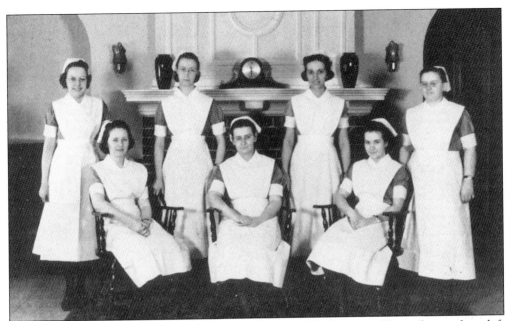

Pictured is Easton Hospital's February 1939 group of student nurses. Those shown, from left to right, are as follows: (front row) Misses Murtha, Drumbeller, and Miller; (back row) Misses Moses, Miner, Heeter, Lupelli, and Sanderson. (Courtesy of Easton Hospital.)

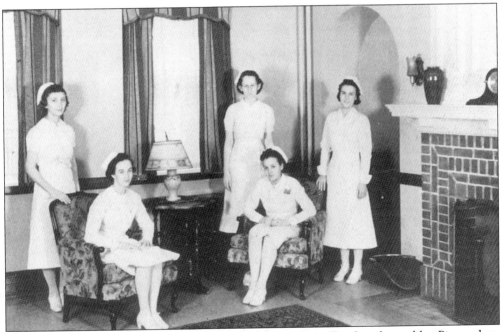

Head nurses at Easton Hospital had a busy job, supervising staff and students alike. Pictured are 1939's supervisors, all registered nurses. Shown, from left to right, are the following: Virginia Clay, assistant supervisor, operating room; Ruth Gallagher, night duty, maternity ward; Mildred Kresge, assistant to supervisor; Eileen Connally, assistant to supervisor, receiving ward; and Marie McGowen, supervisor, operating room.

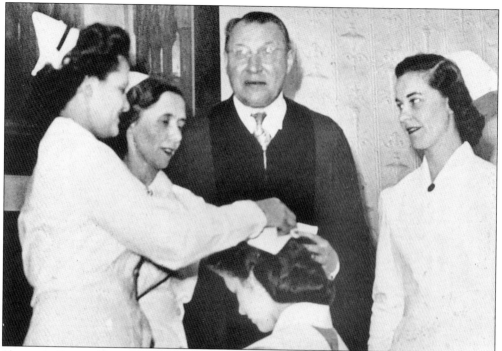

Shown is Easton Hospital's School of Nursing 1950 capping ceremony, the first milestone presented in a student nurse's career. After six months of intensive training, the future nurse made the pledge to Florence Nightingale and received the nurse's cap with a design distinctive to each school of nursing.

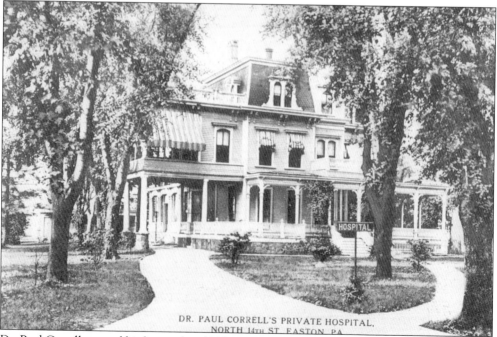

DR. PAUL CORRELL'S PRIVATE HOSPITAL,
NORTH 14th ST. EASTON PA.

Dr. Paul Correll opened his hospital in 1915 on Fourteenth and Bushkill Streets, occupying the former residence of F.W. Coolbaugh. He closed the hospital in 1925.

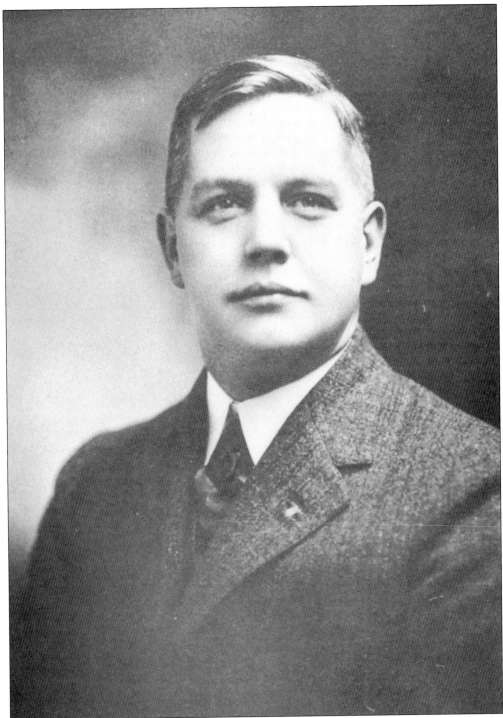

An Easton native, Dr. Correll graduated from Medico-Chirurgical Hospital in Philadelphia. He joined the staff of Easton Hospital in 1924, and later became chief of the surgical staff, introducing the open system of staff membership for physicians. At the 1925 closing of his private hospital, he donated all his equipment and his private ambulance to Easton Hospital.

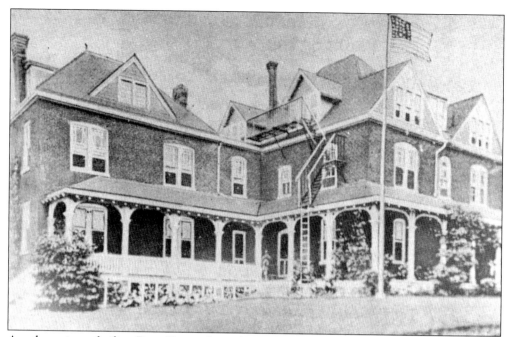

Another private facility, Betts Hospital, was located on the south side of Washington Street. It took over the building of the Easton Home for Friendless Children that had previously opened in the building in 1896. Betts opened in January of 1921 and closed March 23, 1972.

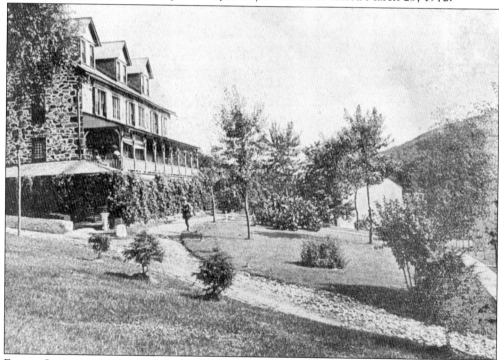

Easton Sanitarium was established in 1895 on North Delaware Drive and Taylor Avenue in Easton. Dr. C. Spence Kinney purchased the sanitarium in 1900. The Nevin Park apartments are located here today.

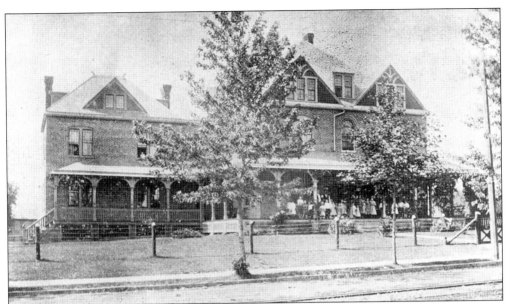

Easton cared for its needy children by opening its Home for Friendless Children on December 28, 1885. The home was made possible with the help of generous donors such as Theodore Sitgreaves and Mrs. William Firestone, who donated an entire block on Washington Street.

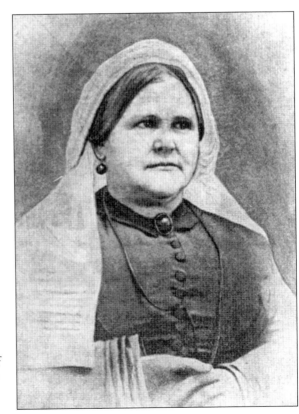

Mrs. Andrew Reeder presided over the Easton Sanitary Society, which provided supplies for sick and wounded Civil War soldiers. Many of the "ministering angels" in her group visited the front and personally tended to the afflicted.

Mrs. Josiah P. Hetrick served as president of the Ladies' Aid Society during the Civil War. After the December 13, 1862 Battle of Frederickburg, her group delivered two tons of food and clothing to soldiers. The group continued their tireless efforts throughout the war.

In 1871, Asher J. Odenwelder purchased the oldest established drug business, known as J.F. Thompson and Company, and named it Odenwelder's Drug Store. Odenwelder acquired his education as a registered pharmacist at Philadelphia's School of Pharmacy. His son, Asher Jr.—a graduate of Lafayette College and the same school of pharmacy—later joined him in the business. In 1908, the store moved to 404–406 Northampton Street.

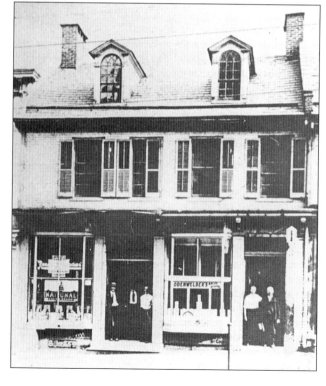

110

Nine

KEEPING THE FAITH

The German Reformed church, built in 1776, was the largest building in Easton at the time. Rev. John William Ingold became pastor shortly after its dedication. The church was used as a hospital for wounded soldiers from the battles of Brooklyn and Brandywine. George Washington visited these servicemen during their stay. Today, the Third Street church, known as the First United Church of Christ, remains as Easton's oldest existing church building. The Lutheran and Reformed Churches were the first to appear in Easton, reflecting its early German Protestant population and the dedication of its ministers in promoting their faith. The Scotch Irish heavily inhabited the region, and Presbyterian churches appeared next. England's penal code discriminated against Catholics, and even after it was abolished, strong anti-Catholic feelings prevailed into the 1830s. Easton congregations have an interesting tendency to adopt the former buildings and locations of other faiths and utilize them for their own worship.

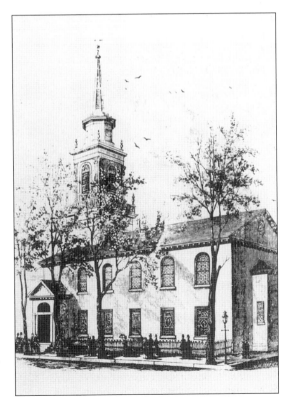

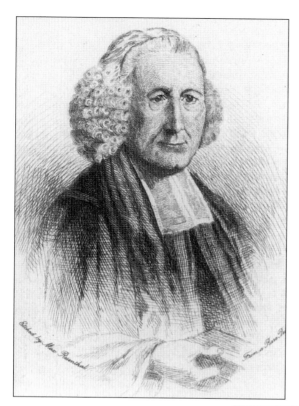

Henry Melchior Muhlenberg, known the "Father of Lutheranism in America," founded a church called the Congregation on the Delaware River Belonging to the Lutheran Religion. The church appears to have begun services as early as 1730. Reverend Muhlenberg served as pastor from 1745 to 1748. The church was situated at the foot of Morgan's Hill, about where the present-day large concrete storage tanks are located.

Rev. Thomas Pomp took over as pastor of the German Reformed Church in 1796, where he remained as minister for over 50 years. He was the only son of Rev. Nicholas Pomp, one of the early German Reformed ministers in America. Both father and son are buried in Easton Cemetery.

112

The Brainerd-Union Presbyterian Church, later the First Presbyterian Church, was built in 1872 as the American Reformed Church of Easton. It went through various changes until it joined with the First Presbyterian Church at Bushkill and North Second Streets, taking on the First Presbyterian Church's name and its congregation.

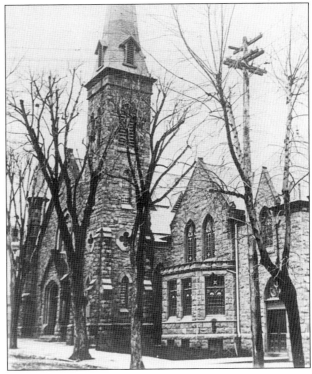

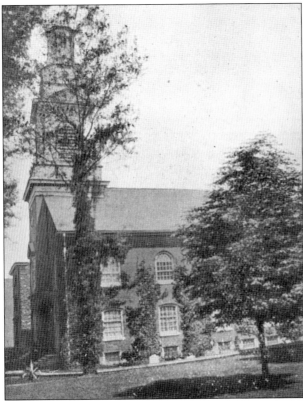

In 1832, Lutherans sold their interests in the German Lutheran and Reformed Church on North Pomfret Street (now Third) Street. They then built the present church, St. John's Evangelical Lutheran Church, on the south side of Ferry Street near Bank Street.

The present First United Methodist Church, located on 34 South Second Street, was built in 1855. In 1826, Methodists began services in the old Union Academy School on North Second Street, presently the site of the Wolf Building. They subsequently purchased the old armory building on South Second and Pine Streets and renovated it. It served as their place of worship until this newer church was built on its site.

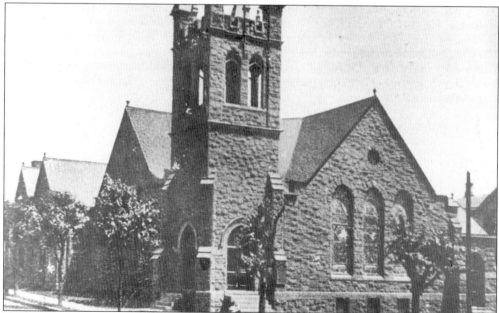

The Olivet Presbyterian Church at Twelfth and Northampton Streets originated as an offshoot of the First Presbyterian Church. Originally organized in 1881 as the First Presbyterian Sunday School, the congregation moved to Northampton Street and opened a chapel. The present church, built in 1904, took on its current name of Olivet United Presbyterian Church 70 years later.

On August 21, 1836, Bishop Kenrick—assisted by Father Herzog, Father Carter, and Father Wainright—dedicated St. Bernard's Roman Catholic church on Gallows Hill, a former execution site on South Fifth Street. This location was all the congregation could afford or was available to them at the time.

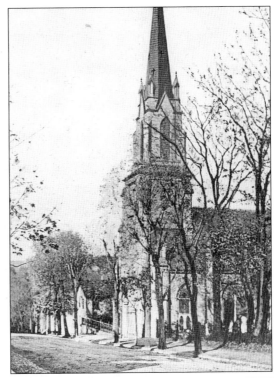

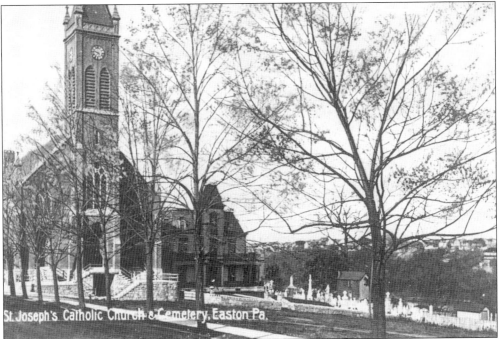

This 1911 view shows St. Joseph's Roman Catholic Church, an offshoot of St. Bernard's. St Joseph's congregation formed in 1852 and built its church a year later at Davis and St. Joseph Street. The 1852 church was razed in 1890 to provide a new church building. However, a 1911 fire completely destroyed that church, and the present chapel was completed in 1918.

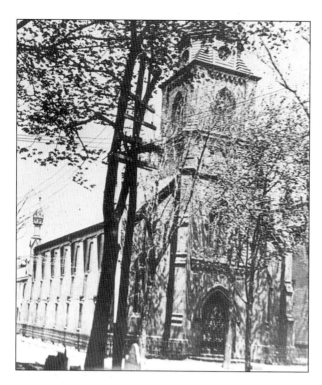

St. Michael's Roman Catholic Church took over the former Brainerd Presbyterian church building on Spring Garden and Sitgreaves Street in *c.* 1919.

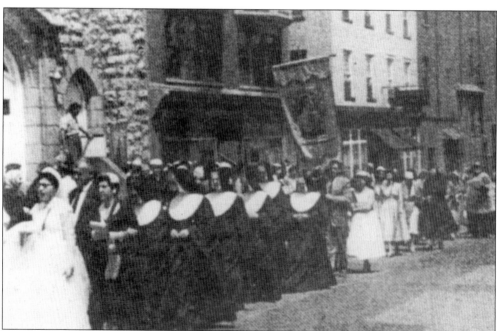

This 1940 church procession passes in front of Our Lady of Lebanon church, then located between Third and Fourth Streets. St. Anthony's Roman Catholic Church purchased the Hebrew Mutual Aid Synagogue in 1915 and razed the building. Our Lady of Lebanon bought St. Anthony's in 1931, remaining there until 1968. The church was later razed during redevelopment.

During the Revolutionary War, more Jewish people inhabited Easton than in any other town or city of the 13 colonies. Their first synagogue, erected in 1842 as the Berith Shalom Covenant of Peace, was built on 40 South Sixth Street. They worshipped there until building the new synagogue in 1959. The Second Baptist Church took over the building in 1965.

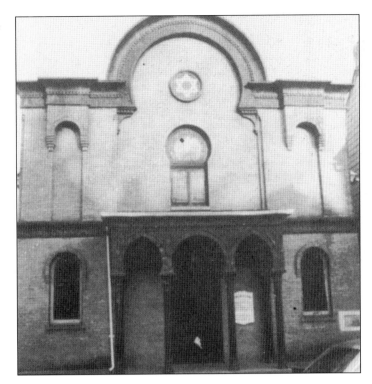

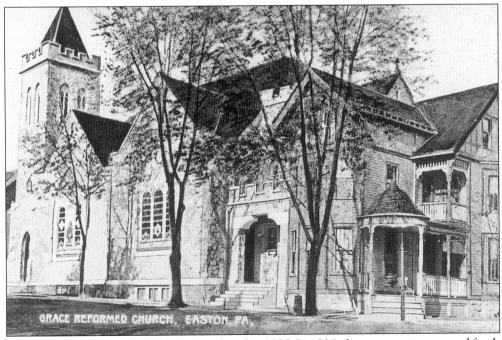

Grace Reformed Evangelical first built a chapel in 1875. In 1906, the congregation secured funds to build a church on the site of the old chapel, and William Marsh Michler designed this church at 411 March Street in Easton. In 1962, it became the Grace United Church of Christ.

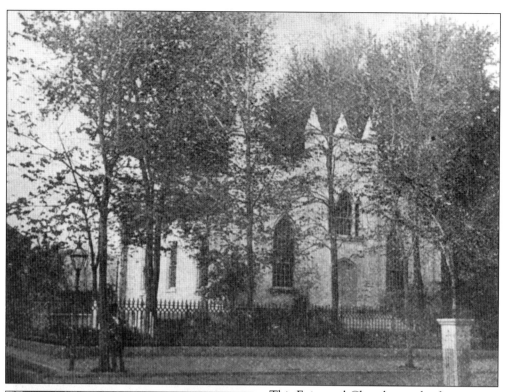

This Episcopal Church was the first to form in Northampton County. The church building was built in 1820 on land donated by the Honorable Samuel Sitgreaves. It was also called the White Church because of its whitewashed exterior. It was razed in 1869 to build a larger church that was subsequently destroyed by fire. Church services in the present Episcopal church, the third to be built on this 234 Spring Garden Street location, commenced in 1876.

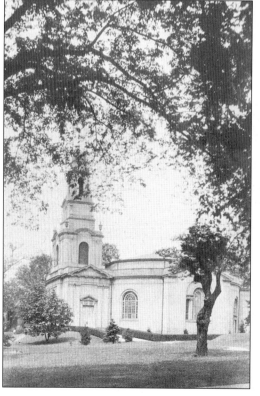

Mrs. Mary Roberts Colton presented Colton Memorial Chapel as a gift to Lafayette College in memory of her late husband. The chapel was dedicated on November 4, 1916.

Ten

EASTON'S UNIQUE
PERSONALITIES

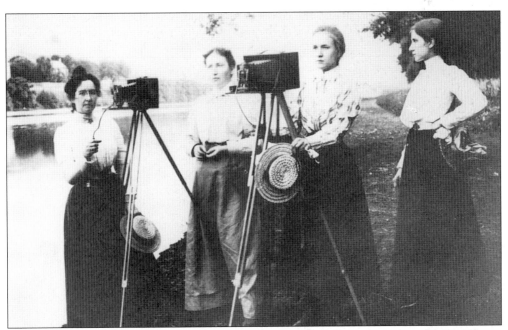

Pictured on the far left, nearest the river, is Norma McFall Collmar, a woman of many talents. Norma's photography has helped to preserve many bygone scenes of Easton history. An 1881 graduate of South Easton High School, she taught in the Easton public schools and became the first supervisor of music of the schools. In addition to her other accomplishments, Norma organized the New Century Club and was organist at the Trinity Episcopal church on Spring Garden Street in Easton. She married Easton physician Dr. Charles U. Collmar, who practiced at Easton Hospital and they had one child, Rida. Norma can be counted among the many unique personalities who, in the past and present, personify the city of Easton.

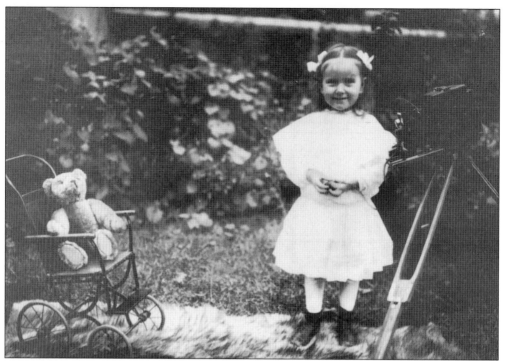

Rida Collmar poses by her teddy bear in 1906. The teddy bear was young then, also, having been conceived several years earlier and named for Pres. Theodore Roosevelt. Born to Norma and Charles Collmar on June 5, 1903, Rida followed her mother's example and also became a teacher in the Easton schools. (Norma Collmar photograph.)

In the days of innocence, Norma Collmar photographed these young girls as they stood before the arch of the Bushkill Creek Bridge. One of them might have been her daughter, Rida. (Norma Collmar photograph.)

Noted stage actress Belle Mingle Archer was the most photographed woman of her time. Born in Easton on June 5, 1859, she died on September 19, 1900.

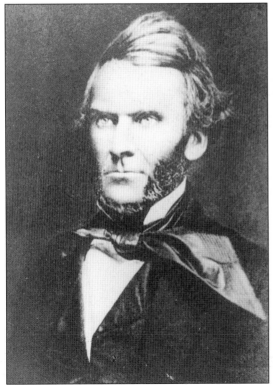

Washington McCartney (1812–1856), a man of many talents, served as a professor of mathematics at Lafayette College, as president and judge of the Third Judicial District, started his own law school in Easton, and was instrumental in establishing Easton's first high school. His wife, Elizabeth Maxwell McCartney, also talented as an artist, preserved many scenes and landmarks of Easton in her sketches and paintings.

This 1888 photograph shows Easton's finest, members of the police department. Shown, from left to right, are the following: (front row) Andrew Bitzer, Sgt. Edward Kelly, Chief Henry C. Tilton, detective James Simmons, and Thomas Stoneback; (back row) Jeremiah Weaver, William Denninger, Isaac Leuber, James Torner, Charles S. Reed, and Samuel Paul.

This c. 1906 photograph shows members of the Northampton County Country Club gathered at the club on the William Penn Highway in Palmer Township. Many of these people fashioned businesses that greatly contributed to Easton's economy.

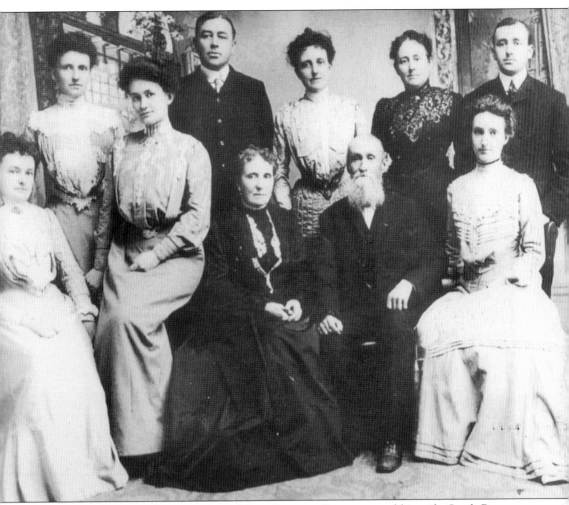

The family of John Appel Seitz, owner of Seitz Brewing Company, and his wife, Sarah Barnet Odenwelder Seitz are shown in this picture. Shown, from left to right, are the following: (front row) Emma Neiman Seitz (1856–1942), Sarah Barnet Seitz (1869–1942), Sarah Barnet Odenwelder Seitz (1831–1920), John Appel Seitz (1830–1911), and Alice Voorhees Seitz (1873–1964); (back row) Annie Marion Seitz (1867–1957), Willie Nelson Seitz (b. 1863), Fannie Odenwelder Seitz (1862–1933), Marie Isabel Seitz (b. 1854), and Frank Karl Seitz (1877–1944). (Courtesy of Barbara Mulholland.)

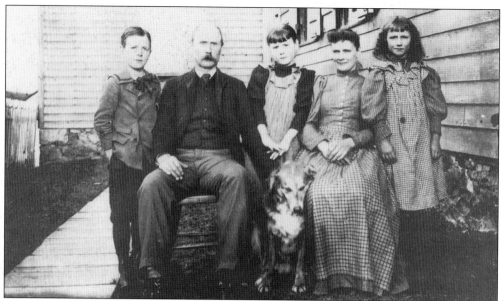

Jesse McFall and his family pose for this April 11, 1897 photograph taken by Norma Collmar. They are believed to be relatives of Collmar, who lived in South Easton and whose maiden name was McFall.

This photograph shows, from left to right, major David Robert Bruce Nevin, Rebecca Cloyd Packer Nevin, Andrew Pierce Nevin, and Mary Pierce Nevin Niebel. Major Nevin, owner of the Paxinosa Inn, built this cottage on Weygadt Mountain near the Paxinosa in 1886 at the same time the inn was built.

Andrew Horatio Reeder displays his humorous side in his disguise as a wood chopper. Born in Easton in 1807, he became one of Easton's most prominent lawyers. President Pierce appointed Reeder as the first territorial governor of Kansas. However, his anti-slavery position antagonized pro-slavery Kansans, and the pro-Southern administration removed him from office. He returned to Easton, where he died in 1864.

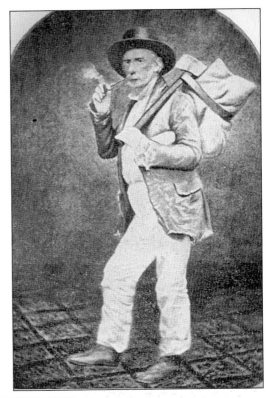

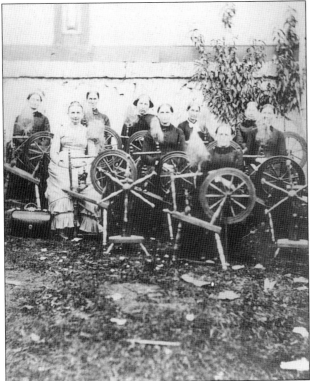

These elderly women display their ability to master the spinning wheel on the last day of the Easton Fair in the late 1890s. They were the only ones still skilled at the ancient art. By then, the world had entered the Industrial Revolution, where machines manufactured cloth they had so laboriously made by hand.

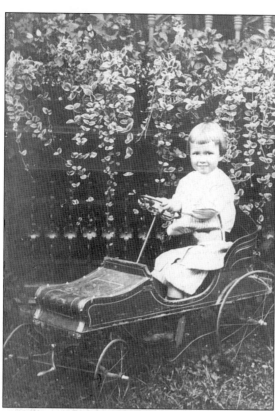

Blaine Young casts his steady cherubic gaze at the camera as he tries out his snappy new roadster in this 1910 photograph.

Ladies at the Easton Public Library work diligently at their task in the binding room of the library. This picture was taken in 1911, nine years after the library was built.

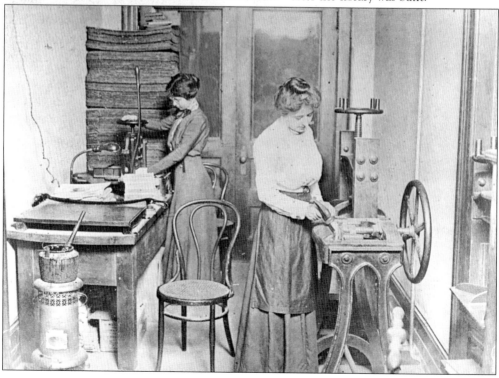

Harvey Mack, founder of Mack Printing, poses with his parents and siblings in this December 25, 1933 picture. Shown, from left to right, are the following: (front row) Frank, Frank W. (Harvey's father), Louella S. (Harvey's mother), and Harvey; (back row) Olive, Robert, and Lena Mack. (Courtesy of the Mack family.)

ACKNOWLEDGMENTS

We would like to express our gratitude to the following individuals and organizations who have spent time with us, lending their valued pictures, use of their facilities, and information. Their response was heartwarming.

George Arnold of Arnold's Studio, Stroudsburg, Pennsylvania.
Binney and Smith.
Cadmus Professional Communications, Cadmus-Mack Division.
The *Express-Times*.
John and Dorothy Eilenberger.
Easton Public Library, with special thanks to the staff of the Marx Room.
Kirk, Summa and Company, LLP, East Stroudsburg, Pennsylvania.
John Wilbur Mack, Paul Mack, and Tim Mack.
Barbara Mullholland.
Northampton County Historical and Genealogical Society.
James and Linda Wright.
Ronald Wynkoop Sr.

We would like to thank our families, who have given us support and inspiration. Thanks also to those artists of long ago who lent their talents to sketches and paintings that helped us recreate visions of the Easton that existed before photography became a reality. This is their legacy to the city now known as Easton.